Lives of

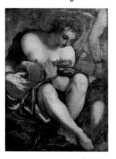

Tintoretto

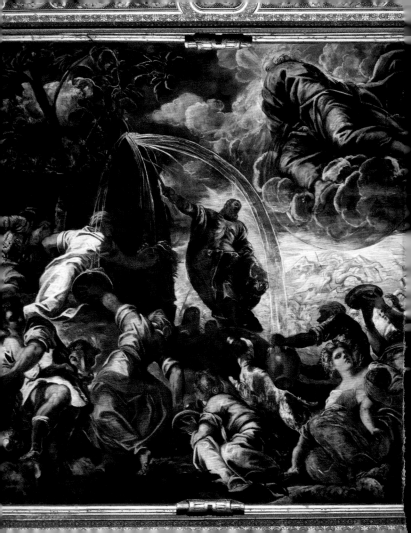

Lives of Tintoretto

Giorgio Vasari

Pietro Aretino

Andrea Calmo

Veronica Franco

Carlo Ridolfi

introduced by
Carlo Corsato

The J. Paul Getty Museum, Los Angeles

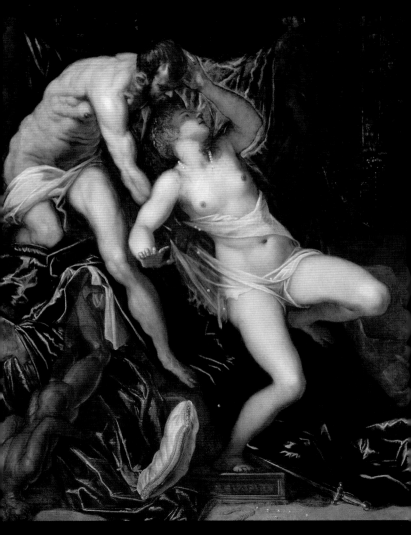

CONTENTS

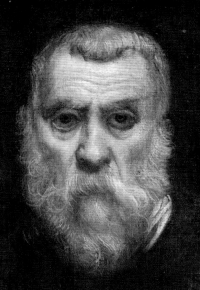

IPSIVS

INTRODUCTION

CARLO CORSATO

On 31 May 1594, a Tuesday and the second day after Pentecost, Jacopo Tintoretto died, the last of the great masters of the Venetian Cinquecento. His artistic vision and industry had dominated Venice for many years; they remain a key part of any understanding of the city. Yet his family was hardly native. The eldest of twenty-two children, he was born about seventy-five years earlier, in either 1518 or 1519. Only ten years before that, Tintoretto's father, Battista Comin, had left Brescia, at the far end of the Venetian territories, together with his brother Antonio, to fight in the defence of Padua against the siege imposed by the emperor, Maximilian I (1509). The great endurance demonstrated by the brothers earned them the nickname 'Robusti' (robust), and Battista adopted this as his family name after moving to Venice. There he became a *tintore di panni* (a cloth dyer) and so the young Jacopo (or Giacomo) grew up playing with pigments and dyes in his father's workshop. He may also

Opposite: Self-Portrait, c. 1588

7

have learnt how to work with apprentices, keep account books, and negotiate with shrewd merchants eager for precious fabrics.

At the age of twenty, Jacopo was already running his own business in the parish of San Cassiano. Everyone knew him then as Giacomo Tintore, after his father's trade; it was only many years later that he came to be called Tintoretto ('the little dyer'), owing to his short stature. In his first self-portrait (opposite), which shows him in his late twenties, he presented himself with that honesty of which only the young and ambitious are capable: dark brown hair, light beard, thick moustache, and a gaze that already reveals the questing purposefulness still so evident in his self-portrait as an old man (Paris, Musée du Louvre, ill. p. 6). His spirited, slightly red-rimmed eyes reveal better than words the reason why Andrea Calmo, in a letter published in 1548, compared him to a peppercorn: Tintoretto was willing to spice up Venetian painting and become its dominant taste.

Only a few years earlier, Calmo — an actor, playwright, and himself the son of a dyer — gave Tintoretto an early break by introducing him to Francesco Marcolini, the publisher of the religious works of Pietro Aretino, the most highly feared tastemaker of the age.

Opposite: Self-Portrait, c. 1546-7

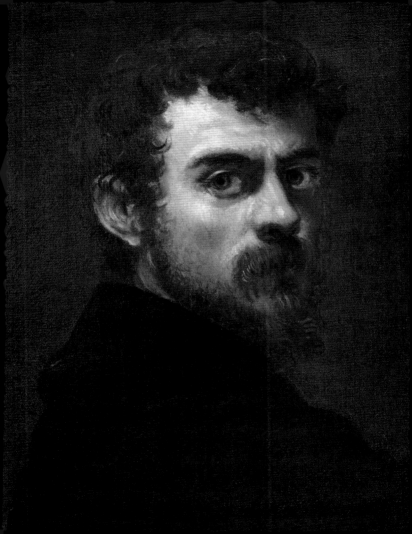

Aretino was an intimate friend of Titian and his biting pen could make or break a young artist's career. But Tintoretto already knew how to make his work appreciated and he obtained the privilege of painting two mythological narratives for a ceiling in the writer's house — *Mercury and Argus* (lost), and *The Contest of Apollo and Marsyas* (ill. p. 52). These are still immature works, their manner recalling that of Bonifacio de' Pitati and Andrea Schiavone, then very fashionable among the younger generation of painters. However, Tintoretto was burningly ambitious to find his own style and escape the anonymity of second-rank painters. Calmo was impressed and wrote that the young painter's name was destined to echo through the bowl of heaven and be carved on the judgment seat of Pluto, god of the underworld. Aretino, too, played his part. In a letter addressed to Jacopo in 1545, he declared that the young man's talent was still green, but that with time, study, and religious reverence, he would come to be worthy of the highest praise.

That promise became reality just three years later. In 1548, thanks to the support of Calmo and of Marco Episcopi (later Tintoretto's father-in-law), the painter obtained a commission that marked the watershed in his career. This was to paint the *Miracle of the Slave* for the Scuola Grande di San Marco (ill. pp. 56-57). The miraculous and spectacular rescue of the slave, a devotee

of Saint Mark, from terrible torture was transformed into an equally jaw-dropping painting. Daringly foreshortened figures, a skilfully synthesized narrative, sophisticated references to the sculptural and architectural language of Jacopo Sansovino and Michelangelo were further enlivened by the masterly juxtaposition of vibrant colours that ratchet up the dramatic tension.

The result was such that Aretino felt compelled to write him another letter of congratulation. But this time, Tintoretto had to content himself with bittersweet praise. Aretino reproached him for his *prestezza*, his hasty and rapid execution. It betrayed the impatience of a youthful artist, who could not yet discipline the disruptive power of his creativity. More than simply a critical judgment, this was taking the opportunity to cut Tintoretto down to size; at this point he was, after all, a man in his thirties, hardly the callow youth implied by Aretino's sneers. No doubt the criticism was damaging to the painter, who struggled to get his career off the ground in the following ten years; but it also laid bare the inability of the older generation to understand the modern way of painting, its emphasis on drama and lack of interest in delicate finish. Regardless of the fact that over the next thirty years Titian would become the master of an even quicker and less finished style, it was Tintoretto who over the centuries would remain famous

as the painter of *prestezza*, too careless and impatient to bring his pictures to a proper degree of polish.

Such criticism notwithstanding, Tintoretto's reputation after only a few years as an independent painter could now stand comparison with that of the great names of the Tuscan-Roman School; indeed, the art writer Paolo Pino mentioned Giacomo Tintore alongside Perugino, Leonardo, Raphael, and Pontormo in his *Dialogue on Painting* (1548). 'In the list, however, I do not include either Michelangelo or Titian,' Pino explained, 'because I regard them as gods and masters of the painters, and I say this truly without any animosity whatsoever.'

Giorgio Vasari, by contrast, seems to have nutured some animosity towards Tintoretto's work when he published the first biography of Tintoretto in the second edition of the *Lives of the Most Eminent Painters, Sculptors and Architects* (1568). The artist was portrayed as an eccentric personality, 'the most non-conforming mind (*terribile cervello*) that the art of painting has ever produced'. He had neither the affected grace of Raphael nor Michelangelo's ability to inspire awe and terror (his *terribilità*). In fact Vasari found himself repelled by Tintoretto's paintings when he saw them. They appeared to him to have been designed without any rational draughtsmanship, as if the artist intended to paint

under the inspiration of Nature, but without following any method, not even the crude and imperfect manner of his Venetian predecessors. The fact that Tintoretto had flooded the majority of the palaces, churches, and confraternities with his fanciful paintings confirmed Vasari's prejudice that in Venice very few people knew what good painting was.

Such a severe and superficial judgment was partly due to haste. Vasari's biography of Tintoretto was written after 1566, when the Venetian artist was admitted to the rank of honorary membership of the Florentine Drawing Academy. By that time, the publishing plan of the *Lives* was already in progress and there was little time to carry out any in-depth research. Had Vasari been more cautious, he might have been spared the bitter criticisms of readers such as the great artist Doménikos Theotokópoulos, better known as El Greco, which, fascinatingly, have survived. Around 1568, while Vasari was trying to complete the *Lives*, El Greco was in Venice, where he could properly study the works of Tintoretto and Veronese in the Doge's Palace, later burnt in the fire of 1577 that also destroyed the celebrated *Battle of Cadore* by Titian. It was this terrible accident, however, that then gave Tintoretto the opportunity to paint the most grandiose of his later compositions, the *Paradise* for the Hall of the Great Council (Sala del Maggior

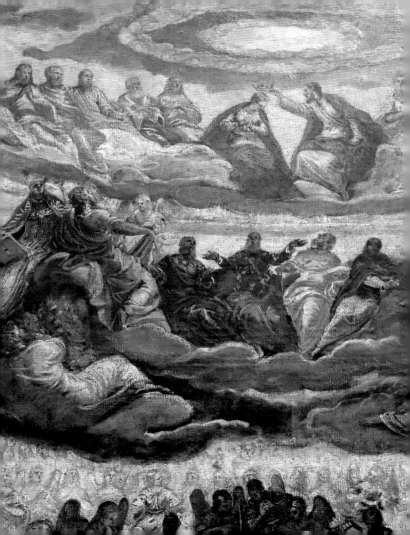

Consiglio), in which countless floating figures dance within the concentric circles of the paradisiacal cloud-scape, expressing the grandeur of both God and the Republic of Venice, like an orchestra playing a triumphal march at full tilt (ill. pp. 224-26 with detail p. 227).

By the time the *Paradise* was completed (1588-92), El Greco was already in Spain and had started annotating his copy of the *Lives* — one previously owned by the painter Federico Zuccari (Madrid, Biblioteca Nacional de España). In his notes, El Greco proclaimed the *St Roch Cures the Plague Victims* (ill. pp. 36-37) to be 'the best [painting] in the world since the loss of Titian's *Battle*'. There was no mention of Tintoretto's *prestezza*, although the canvas had been painted only a year after the *Miracle of the Slave*. Even Vasari had appreciated the *St Roch*, in particular its convincing foreshortening and some of the nude figures, which he thought well conceived. This solitary appreciative comment did not, however, inoculate Vasari against the animosity of El Greco, who could not forgive him for relegating the account of Tintoretto to a secondary appendix in the *Life* of Battista Franco. No matter that El Greco had studied and reused some compositions by Battista Franco; the issue was that Franco — in spite of being a Venetian artist — had converted

Opposite: Detail from a sketch for the Paradise, c. 1577

15

to the manner of Raphael and Michelangelo. Availing himself of a generous white space at the end of this biography, El Greco vented his anger with caustic irony: Battista Franco deserved to be the main character of this *Life*, he declared, only because Franco's limited artistic qualities would never afford him any other recognition.

In the same period, this same resentment came to be shared by the painter Annibale Carracci. In his own copy of the *Lives* (Bologna, Biblioteca dell'Archiginnasio), at the beginning of the *Life* of Battista Franco, Carracci wrote a lapidary, and quite possibly defamatory, remark:

> Battista Franco was nothing more than a mediocre painter and not as excellent as he is commended by the ignorant Vasari; but he must have been a friend of Vasari's, or Vasari must have received some *scudi* from him, since Giorgio was truly avaricious.

At the end of the biography, taking advantage of the same blank space of the last page in his copy of the *Lives*, Carracci redoubled the dose of venom:

> But what should I say of this ignorant and envious Giorgio, not having [enough] space [here]? Just as [he did] with Paolo Veronese, he gets away with it by writing only three or four words on the most excellent Jacopo Tintoretto, a painter truly worthy of mention

by the most famous writers for his utterly stupendous works.

Vasari's perceived neglect and animosity fomented an overheated artistic debate, as the courtesan and writer Veronica Franco had been able to observe. In a letter to Tintoretto, published in 1580, Franco criticised the obsession with holding the artists of the past in higher esteem than those of the present. Similarly reprehensible was the mistaken belief that Michelangelo, Raphael, and Titian were superior to Tintoretto, since all these painters, in their own style, had known how to equal, if not surpass, the great artists of antiquity. Franco's words in fact seem to imply that the Florentine and Venetian Schools should be able to declare a kind of artistic truce, in which Tintoretto could be seen to be the equal not just of Vasari's two heroes of the modern manner, but also of Titian, whose art of colouring clothed his sitters in flesh and blood. In support of her claims, Franco cited the portrait that Tintoretto has made of her — now lost, but probably similar to the *Portrait of a Lady* by Tintoretto's son Domenico (Worcester Art Museum, ill. p. 66). The painting was such a striking likeness that it seemed to be the work of witchcraft. *Natura potentior ars* — art is more powerful than Nature, as Titian's motto had it.

Despite these voices raised in his favour, there is no

doubt, however, that Tintoretto struggled to gain the limelight. Though beloved by his clients, he was not able to attract the sympathies of the literary mainstream while alive. It was not until almost fifty years after his death that the painter and art writer Carlo Ridolfi provided a hugely detailed account of all his works in his *Life of Giacomo Robusti called Tintoretto: Celebrated Painter and Venetian Citizen* of 1642, which he later republished in the *Marvels of Art* (1648). In Ridolfi's account, Tintoretto is the embodiment of the perfect modern painter, the only one able to synthetize 'Michelangelo's draftsmanship and Titian's art of colouring' (though it seems improbable that Tintoretto actually wrote this tag on the wall of his workshop, as Ridolfi reports). Moreover, he certainly knew far more about classical antiquities and mastered drawing far better than Vasari gave readers to understand. Not only did he copy drawings of Michelangelo's sculptures in the Medici Chapel (as in the example opposite), but he also studied antiquities (as we see in, for instance, the *Head of Emperor Vitellius* on p. 20). In fact Tintoretto drew prolifically, always with the aim of using strong chiaroscuro and dramatic lighting to express human anatomy (e.g. *Studies of a Statuette of Atlas*, J. Paul Getty Museum, Los Angeles; ill. p. 77).

Opposite: Head of Giuliano de' Medici, after Michelangelo, c. 1540

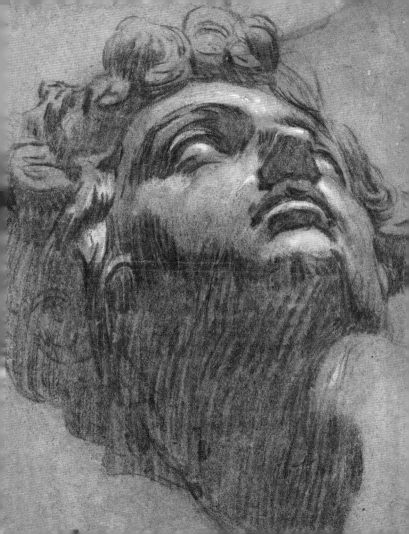

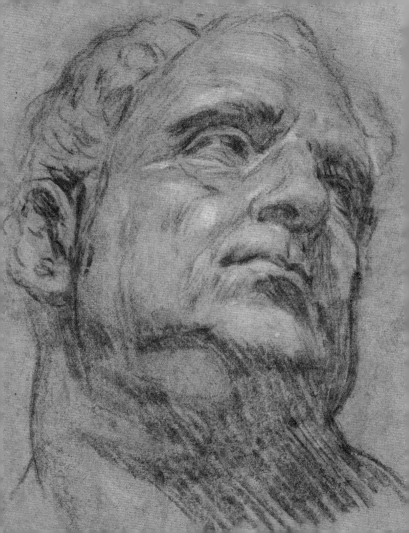

In the end, the primacy of anatomy was the lesson Tintoretto learnt from Michelangelo's *disegno,* to which he added the softness and sensuality of Titian's *colorito* – his use of colour. The result was a personal style that culminated in masterpieces such as *Susannah and the Elders* (ill. pp. 210-11).

In fact Ridolfi claimed that Titian had been Tintoretto's master but for a very short period only, driving him away from the workshop out of jealousy at his talent. As enjoyable as this anecdote is, it is most implausible, and seems to have been introduced to disguise the fact that Tintoretto was largely self-taught, apart from a possible short apprenticeship with some little-known master. Even today the early stages of Tintoretto's career are a mystery; he presumably worked as a subcontractor for other masters, specialising as a fresco painter and as a decorator. But little survives: even by the mid seventeenth century, most of the frescoes mentioned by Ridolfi were already decaying. Just a handful of fragments from Ca' Soranzo dell'Angelo at the Ponte del Remedio are still extant (Venice, private collection). The internal decorative cycles would have shared the same fate; only a few have come down to us, such as the canvases of the *Fables of Ovid* for Ca' Pisani in San Paternian (ill. p. 188).

Opposite: So-Called Head of Emperor Vitellius, c. 1540-80

But we can see that the daringly foreshortened figures of this series anticipate by a few years Titian's famous perspectival experimentation in the ceiling decoration of the church of Santo Spirito (now in the Church of the Madonna della Salute, Venice).

It is the public commissions undertaken from the end of the 1540s that constitute the core of Tintoretto's output, as catalogued by Ridolfi with the minute precision of a dedicated fan. His reputation was established by his work for the Venetian churches and confraternities. At San Marcuola he began with a weak *Last Supper* (in situ), though he later rewarded their trust with an extraordinary *Christ Washing the Feet of the Disciples* (ill. pp. 86-87), in which a powerful and audacious perspective — directly taken from Sebastiano Serlio's *Stage Scene for Tragedy* (1545) — defines the space in which the story unfolds like a sacred drama. Perhaps the most incredible achievement can be found in the church of the Madonna dell'Orto, within a stone's throw of the painter's second (and last) house. The organ shutters show a moving *Presentation of the Virgin* (ill. pp. 42-43), dominated by a staircase, worked over with elaborate decoration in gold leaf. And in the two huge canvasses in the presbytery — *The Last Judgment* (ill. opposite, details pp. 97

Opposite: The Last Judgment, c. 1559-60

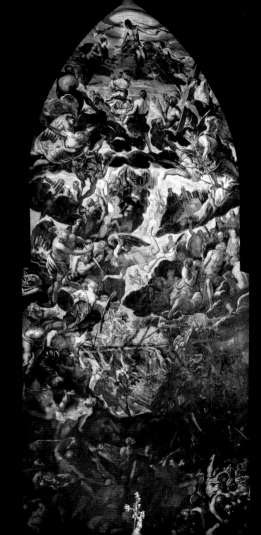

details pp. 97 and 98) and *The Making of the Golden Calf* (ill. p. 38)— Tintoretto's creativity seems inexhaustible. Hundreds of finely painted details breathe a sublime life into these two religious narratives that is reminiscent of the *terribilità* of Michelangelo.

According to Ridolfi, the painter might have offered to undertake this commission for no reward. This would seem to be another unlikely anecdote, if we did not know that in 1574 Tintoretto had agreed to paint the Battle of Lepanto in the Doge's Palace (lost) for the cost of the materials only. In that case, however, the painter had asked and obtained from the Republic the profitable *sanseria* (a lifelong broker's licence), as had Titian about sixty years earlier. He also for years enjoyed a virtual monopoly on the provision of portraits and devotional paintings to the most disparate collection of institutions. Though not very remunerative in itself, this trade created an excellent network, which on the one hand guaranteed him the support of the Venetian intelligentsia (such as Vincenzo Morosini, ill. opposite) and on the other enabled him to access the more profitable decorative campaigns in the Doge's Palace (ill. pp. 163, 173, and 176). Among these were the allegorical cycles, battles, and paintings celebrating various doges who gave

Opposite: Portrait of Vincenzo Morosini, c. 1580

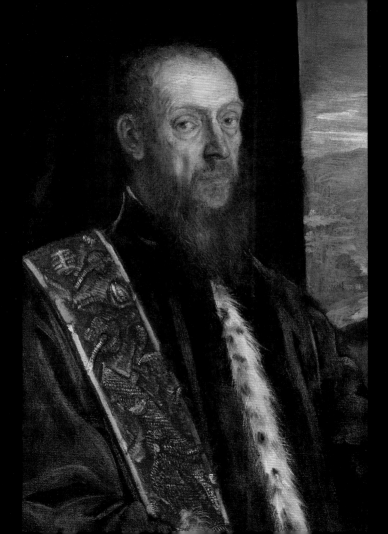

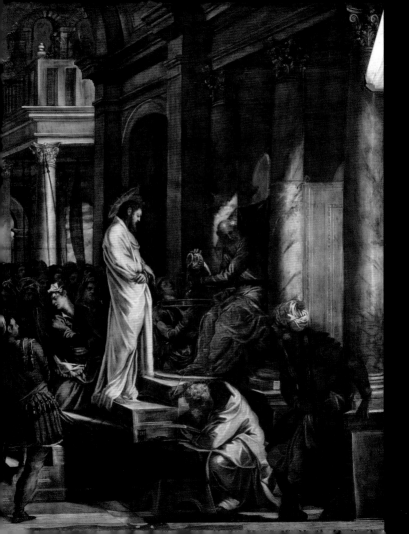

work to Tintoretto and his workshop for almost three decades.

It is not in the Palace, however, that Tintoretto created his most personal and overwhelming work, but in the Scuola Grande di San Rocco. Whilst favoured by the Brescian origins of his family, which were shared by many members of the confraternity, the painter had to wait until 1564 before obtaining the commission that would open to him the doors of the Scuola. According to Ridolfi, a contest was announced that year for a painting of St Roch in Glory. Paolo Veronese, Andrea Schiavone, Giuseppe Salviati, and Federico Zuccari also took part. While they were preparing their sketches, Tintoretto not only had the impudence to enter the Scuola overnight and install a completed painting of the subject, but also presented it as a gift, to forestall any possible refusal. Ridolfi's anecdote is undoubtedly fantastical, but what is certain is that Tintoretto had to work hard to persuade those brothers who had wanted a painting by Titian, himself still a member of the confraternity. In the end, Tintoretto was preferred, and he painted a breathtaking *Crucifixion* (ill. pp. 122-24 with detail p. 125), as well as every inch of the remaining walls with the stories

Opposite: Christ before Pilate, 1566-67, from the cycle in the Scuola Grande di San Rocco

of Christ (on the upper floor) and of the Virgin (on the ground floor).

Tintoretto continued to work at San Rocco for a quarter of a century. In later years, as age caught up with him, he was increasingly helped by assistants, especially his first-born son, Domenico. When the end came, he entrusted the business to Domenico, and expressed the hope that his youngest, Marco, might continue with the art of painting, instead of pursuing the career of an actor. (Marco never came good; the other talented child, his natural daughter Marietta, had died only just before her father.) To his wife, Faustina Episcopi, twenty-five years his junior, he left his few possessions; she was also charged with the care of their numerous children. The will, dictated after a fortnight of fever, has no famous words to bequeath to history, only the instructions of a consciencious father and businessman. Nor were there grandiose memorial tributes; Ridolfi reported that only a handful of artists, friends and family members attended the funeral service in the church of the Madonna dell'Orto. Tintoretto, master of drama and emotion, passed away without clamour.

Giorgio Vasari

Life of Tintoretto

from
The Life of Battista Franco

1568

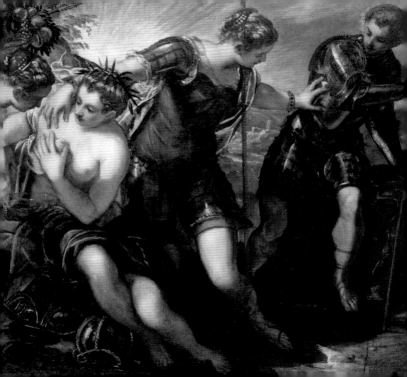

In the same city of Venice, and about the same time as Battista Franco, there lived, as he still does, a painter called Jacopo Tintoretto, who has delighted in all the arts, and particularly in playing various musical instruments, besides being agreeable in his every action, but in the matter of painting extravagant, fanciful, swift, resolute, and the most non-conforming mind [*terribile cervello*] that the art of painting has ever produced, as may be seen from all his works and from the compositions of his fantastic narrative scenes [*storie*], executed by him in a fashion of his own and contrary to the use of other painters. Indeed, he has surpassed even the limits of extravagance with his new and fanciful inventions and the strange vagaries of his intellect, working with no proper method or draftsmanship [*disegno*], as if to prove that art is but a jest. He at times has left sketched works as if they were finished, still so roughly formed that the brushstrokes may be seen, done by instinct and chance rather than with judgment and design.

He has painted almost every kind of picture, in fresco and in oils, including portraits from life, and at every price, insomuch that with these methods he has

Opposite: Minerva protecting Peace and Abundance from Mars, 1578

executed, as he still does, the majority of the pictures painted in Venice. And since in his youth he proved himself by many beautiful works a man of great judgment, if only he had recognised how great a talent he had from Nature, and had improved it by reasonable study, as has been done by those who have followed the beautiful manners of his predecessors, and had not dashed his work off by mere skill of hand, he would have been one of the greatest painters that Venice has ever had. Not that this prevented him from being an instinctive and able painter, and quick-witted, fanciful, and gentle in spirit.

Now, when it had been decreed by the Senate that Jacopo Tintoretto and Paolo Veronese, at that time young men of great promise, should each execute a narrative scene in the Hall of the Great Council, and Orazio Vecellio, the son of Titian, another, Tintoretto painted in his canvas Frederick Barbarossa being crowned by the Pope Adrian IV, depicting there a most beautiful building, and about the Pontiff a great number of cardinals and Venetian gentlemen, all portrayed from life, and at the foot the Pope's chapel of music.[1] In all this he acquitted himself in such a

1. *Pope Adrian IV Crowning Emperor Frederick Barbarossa*, 1553, lost in a fire (1577)

manner that the picture can bear comparison with those of the other illustrious artists, including that of the said Orazio, in which there is a battle that was fought at Rome between the Germans of that Frederick and the Romans, near the Castel Sant'Angelo and the Tiber. In this picture, among other things, there is a horse in foreshortening, leaping over a soldier in armour, which is most beautiful; but some maintain that Orazio was assisted in the work by his father Titian.*

Beside these canvases, Paolo Veronese, of whom there has been an account in the *Life* of Michele Sanmicheli, painted in his scene the said Frederick Barbarossa presenting himself at court and kissing the hand of Pope Octavian, in contempt of Pope Alexander III; and, in addition to that narrative, which was very beautiful, Paolo painted over a window four large figures: Time, Unity, with a bundle of rods, Patience,

* *Marginal note by El Greco made in the* Life *of Titian,* referring to this passage in the Life of Tintoretto *and confusing Orazio's* Battle of Castel Sant'Angelo *with Titian's* Battle of Cadore: This, my good man, is the picture you said in the Life of Tintoretto *was done by Orazio, the son of Titian: it is ridiculous to have praised it and to praise it now as a work by Titian, and say that it is the finest of what is in that hall of the Great Council. What I understand is that you must have eyes in the back of your neck, and that being the case, you present it as if were the finest painting in the world, but it was as pleasing to you as it was to the fire that burned it.*

and Faith, in which he acquitted himself better than I could express in words.*

Not long afterwards, another narrative scene being required in that hall, with the help of friends and other means Tintoretto so solicited the commission that it was given to him; whereupon he executed it in such a manner that it was a marvel, and that it deserves to be numbered among the best things that he ever did, so powerful in him was his determination that he would equal, if not vanquish and surpass, his rivals who had worked in that place. And the narrative he painted there, to the end that it may be understood also by those who are not of the art, represented Pope Alexander III excommunicating and interdicting Barbarossa, and the latter therefore forbidding his subjects to render obedience any longer to the Pontiff.[1] And among other fanciful things in this scene, that part is most beautiful in which the Pope and the cardinals are throwing down torches and candles from a high place, as is done when some person

* El Greco: So from this one can tell that Vasari fails to distinguish the manner of one from the other, because […] these works are by Tintoretto, and he presents them as by Veronese; their manners couldn't possibly be more different.

1 Pope Alexander III Excommunicating Emperor Frederick Barbarossa, 1553, lost in a fire (1577)

is excommunicated, and below is a rabble of nude fig-
ures that are struggling for those torches and candles,
the most lovely and beautiful painted scene in the
world. Besides all this, certain pedestals, antiquities,
and portraits of gentlemen depicted throughout the
scene are executed very well, and won him favour and
fame with everyone.

For the main chapel of the church of San Rocco
he therefore painted, just below the works of Gio-
vanni Antonio Pordenone,[1] two pictures in oils as
broad as the width of the whole chapel, about twelve
braccia each. In one he depicted a view in perspective
as of a hospital filled with beds and sick persons in
various attitudes who are being healed by St Roch;
and among these are some nude figures very well
conceived, and a dead body in foreshortening that is
very beautiful.[2] In the second picture there is another
narrative of St Roch, full of most graceful and beau-
tiful figures, and such, in short, that it is held to be
one of the best works that this painter has ever exe-
cuted.[3] In a narrative of the same size, in the middle
of the nave of the church, he painted Jesus Christ
healing the infirm man at the pool of Bethesda,

1. 1528-29, lost 2. *St Roch Cures the Plague Victims*, 1549, in situ, ill.
overleaf. See El Greco's comment on p. 50 3. *St Roch in Prison Com-
forted by an Angel*, 1567, in situ; ill. pp. 114-15

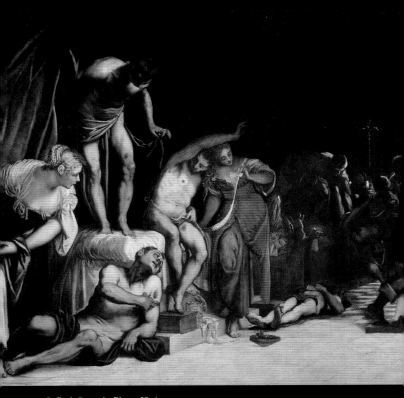

St Roch Cures the Plague Victims, 1549

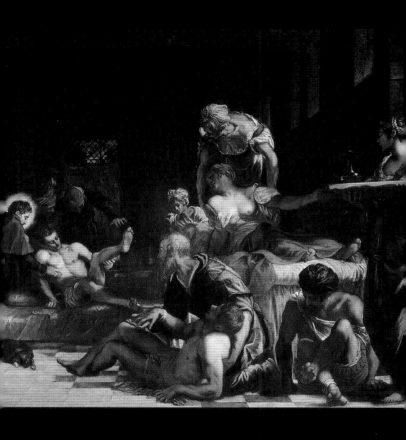

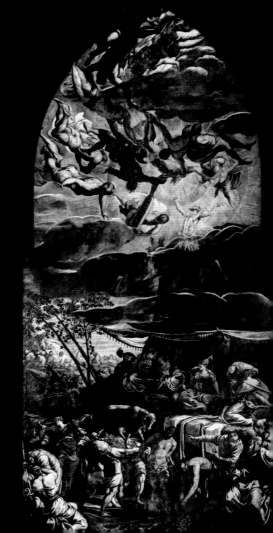

which is also a work held to be well-proportioned.[1] In the church of Madonna dell'Orto, where, as has been related above, Cristoforo Rosa and his brother Stefano, painters of Brescia, painted the ceiling, Tintoretto has painted (on canvas and in oils) the two walls of the main chapel, which are twenty-two *braccia* in height from the vaulting to the cornice at the foot. In that which is on the right hand side he depicted Moses returning from the Mount Sinai, where he had received the Tablets of the Law from God, and finding the people worshipping the Golden Calf;[2] and opposite to that picture, in the other canvas, there is the Universal Judgment of the last day,[3] painted with an extravagant composition [*invenzione*] that truly has in it something awe-inspiring and terrible, by reason of the diversity of figures of either sex and all ages that are in there, with glimpses [*strafori*] and distant views [*lontani*] of the souls of the blessed and the damned. There, also, may be seen the boat of Charon, but in a manner so different from that of others, that it is a thing beautiful and

1. *Christ at the Pool of Bethesda*, 1559, in situ 2. *The Making of the Golden Calf*, c. 1559-60, in situ, ill. opposite 3. *The Last Judgment*, c. 1559-60, in situ; ill. pp. 23, 97 and 98

Opposite: The Making of the Golden Calf, c. 1559-60

strange. If this fanciful composition had been designed with correct and well-ordered drawings, and if the painter had given diligent attention to the various parts and to each particular detail, as he has done to the whole in expressing the confusion, turmoil, and terror of that day, it would have been a most stupendous picture. And whoever glances at it for a moment, is struck with astonishment; but, considering it afterwards minutely, it appears as if painted as a jest. The same artist has painted in oils in that church, on the shutters of the organ, the Virgin ascending the steps of the temple, which is a well-finished work, and the best-executed and most gladsome picture that there is in that place.[1] In Santa Maria Zobenigo [Santa Maria del Giglio], likewise on the shutters of the organ, he has painted the Conversion of St Paul, but not with much consideration.[2] In the church of Santa Maria della Carità is an altarpiece by his hand, of Christ taken down from the cross;[3] and in the sacristy of the church of San Sebastiano, in competition with Paolo Veronese, who executed many pictures on the ceiling and the walls of

1. *c.*1556, in situ, ill. pp. 42-43 2. 1557, *The Evangelists Mark, John Luke and Matthew* (inner shutters), in situ, ill. p. 147; *Conversion of St Paul* (outer shutters), lost 3. Lost before 1648

that place, he painted above the vestry cupboards Moses in the desert and other scenes,[1] which were continued afterwards by Natalino da Murano, a Venetian painter, and by others. The same Tintoretto then painted for the altar of the Pietà, in San Giobbe, three Maries, St Francis, St Sebastian, and St John, with a piece of landscape;[2] and, on the organ shutters in the church of the Servites, St Augustine and St Philip, and beneath them Cain killing his brother Abel.[3] At the altar of the Blessed Sacrament in the church of San Felice, or rather, on the ceiling of the tribune, he painted the four Evangelists; and in the lunette above the altar an Annunciation, in the other lunette Christ praying on the Mount of Olives,[4] and on the wall the Last Supper that He had with His Apostles.[5] And in San Francesco della Vigna, on the altar of the Deposition from the Cross, there is by the same hand the Madonna in a swoon, with the other Maries and some prophets.[6] In the Scuola Grande di San Marco, near Santi Giovanni e Polo, are four large scenes by his hand. In one of these there is St

1. Possibly circle of Bonifacio de' Pitati, *Brazen Serpent*, *c.*1550-55, in situ 2. Unidentified or lost 3. Lost, or dispersed after the demolition of Santa Maria dei Servi (1815) 4. All lost 5. 1559, Paris, church of St François-Xavier 6. *c.*1563-64, Edinburgh, National Galleries of Scotland

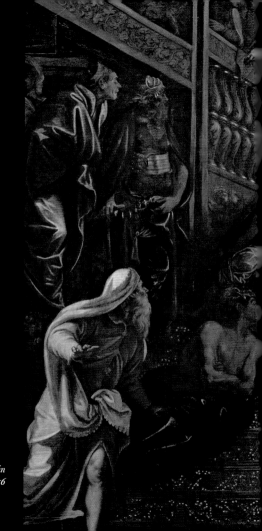

Presentation of the Virgin in the Temple, c. 1556

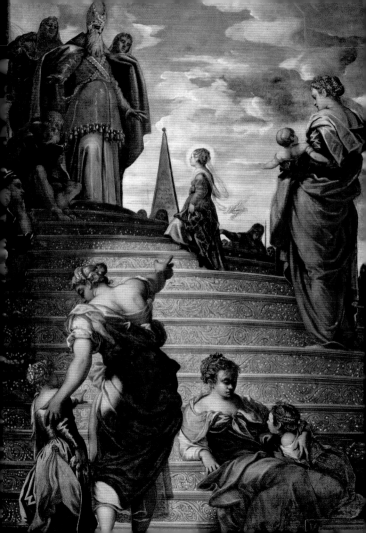

Mark, who, appearing in the sky, is delivering one who is his votary from many torments that may be seen prepared for him with various instruments of torture, which being broken, the rogue of an executioner was never able to employ them against that devout man;[1] and in that scene there is a great abundance of figures, foreshortenings, pieces of armour, buildings, portraits, and other suchlike things, which render the work very ornate. In the second there is a tempest at sea, and St Mark, likewise in the sky, delivering another of his votaries;[2] but that scene is by no means executed with the same diligence as that I already described. In the third there is a storm of rain, with the dead body of another of St Mark's votaries, and his soul ascending into Heaven;[3] and in addition, the figures in this picture are grouped with good balance. In the fourth, wherein an evil spirit is being exorcised, he counterfeited in perspective a great loggia, and at the end of it a fire that lights it up with many reflections.[4] And in addition to those scenes there is on the altar a St Mark by the same hand,

1. *Miracle of the Slave*, 1548, Venice, Accademia; ill. pp. 56-57 2. *St Mark Rescues a Saracen from Drowning*, c. 1564, Venice, Accademia; ill. p. 108 3. *Theft of the Body of St Mark*, c. 1564, Venice, Accademia; ill. p. 107 4. *Finding of the Body of St Mark*, c. 1564, Milan, Brera; ill. p. 104

which is a well-proportioned picture.[1] These works, then, and many others that are here left unmentioned, it being enough to have made mention of the best, have been executed by Tintoretto with such rapidity [*prestezza*] that, when it might be thought that he had scarcely begun, he had finished. And it is a notable thing that with the most extravagant ways in the world, he has always work to do, for the reason that when his connections and other means are not enough to obtain for him any particular work, if he had to do it at a low price, without payment or by any means necessary, in one way or another, do it he would. And it is not long since, Tintoretto having executed the Passion of Christ in a large picture in oils and on canvas for the Scuola Grande di San Rocco,[2] the men of that confraternity resolved to have some honourable and magnificent work painted on the ceiling above it, and therefore to allot that commission to that one among the painters that there were in Venice who should make the best and most beautiful design. Having therefore summoned Giuseppe Salviati, Federico Zuccari, who was in Venice at that time, Paolo Veronese, and Jacopo Tintoretto, they

1. Lost, or untraced 2. *Crucifixion*, 1565, in situ; ill. pp. 122-24 and detail p. 125

ordered that each of them should make a drawing,
promising the work to him who should acquit himself
best in this. While the others, then, were engaged
with all possible diligence in making their drawings,
Tintoretto, having taken measurements of the size
that the work was to be, spread a large canvas over a
stretcher and painted it with his usual rapidity, with-
out anyone knowing about it, and then placed it
where it was to appear. Whereupon, the men of the
confraternity having assembled one morning to see
the drawings and to make up their mind, they found
that Tintoretto had completely finished the work and
had placed it in its intended location. At which being
angered against him, they said that they had called
for drawings and had not commissioned him to exe-
cute the work; but he answered them that this was his
method of making a design, that he did not know
how to proceed in any other manner, and that de-
signs and models of works should always be after that
fashion, so as to deceive no one, and that, finally, if
they would not pay him for the work and for his la-
bour, he would make them a present of it. And after
these words, although he had much opposition, he so
insisted that the work is still in the same place. In this
canvas, then, there is painted a Heaven with God the
Father descending with many angels to embrace St

Roch,[1] and in the lowest part are many figures that signify, or rather, represent the other Scuole Grandi of Venice, such as the Carità, San Giovanni Evangelista, the Misericordia, San Marco, and San Teodoro, all executed in his usual manner.[2] But since it would be too long a task to enumerate all the pictures of Tintoretto, let it be enough to have discussed these above-named works of him, who is a truly able man and a painter worthy to be praised.* (...)

Likewise a good painter in our own day, in that city of Venice, has been Andrea Meldolla called Schiavone; I say good, because unfortunately only at times he has produced some good works, because he has always imitated the manners of the other good masters as best as he could. (...) In the chapel of the Presentation, in the same church, he has painted the Infant Christ presented by His Mother in the temple, with many portraits from life, but the best figure that is there is a woman suckling a child and wearing a yellow garment;[3] she is executed with a particular

* *El Greco: Yes, a painter worthy of praise by those who understand painting, but not by those who deem Tintoretto's taste to be so spoiled and bad.*

1. *St Roch in Glory*, 1564, in situ; ill. p. 46 2. 1564, part of a set of sixteen allegories framing St Roch in Glory; in situ 3. Jacopo Tintoretto, *Presentation of Christ in the Temple*, c. 1550-55, in situ; ill. p. 150-51. Vasari attributed it to Schiavone incorrectly

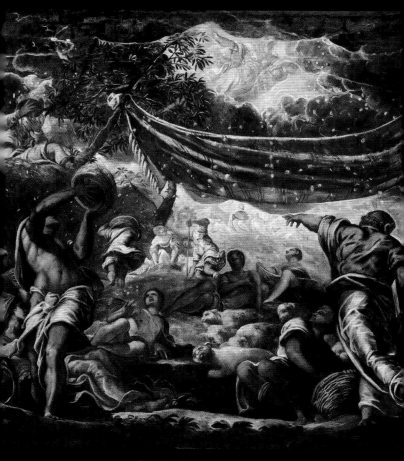

Gathering of the Manna, 1577

method of painting used in Venice, which is carried out dashing off, or rather, sketching the figures, without finishing them completely. From him, in the year 1540, Giorgio Vasari commissioned of a large canvas in oils with the battle that had been fought a short time before between Charles V and Barbarossa Khayr ad-Din Barbarus;[1] and that work, which was one of the best that Andrea Schiavone ever executed, and truly very beautiful, is now in Florence, in the house of the heirs of the Magnificent Messer Ottaviano de' Medici, to whom it was sent as a present by Vasari.*

* El Greco: At least this battle scene will be the greatest work now in Florence; and there can be no doubt of it, because the other things Vasari writes in these Lives are deceiving and spiteful, since there's as much pictorial skill in the worst painting by Tintoretto as clumsiness in the finest by Battista Franco of Venice and Giorgio Vasari. Nevertheless, the painting with the hospital scene Tintoretto did in the church of San Rocco[2] is the best in the world after the loss of Titian's battle in the Doges' Palace.[3] I say the best because of the many and varied things found in it, both in nudes and colouring, which appear nowhere else, unless it be in some of Titian's fine works. And given that this is the truth, just look at the way he writes, putting Jacopo Tintoretto in the Life of Battista Franco of Venice; but let the latter be the main artist of this Life, for he truly cannot get any better credit.

1. *Charles V Destroying Khayr ad-Din Barbarus' Fleet and Capturing Tunis*, 1540, lost 2. *St Roch Cures the Plague Victims*, 1549, in situ. See Vasari's description p. 35 3. *Battle of Cadore*, 1538, lost in a fire (1577). Vasari recorded the painting as the *Battle of Ghiaradadda* (or *Ghiara d'Adda*)

Pietro Aretino

Letters

from

Third and Fourth Book of Letters

published 1546 and 1550

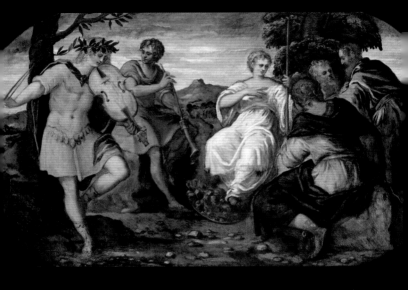

Contest of Apollo and Marsyas, 1544-45

To Messer Jacopo Tintore

All connoisseurs agree that the two fables, that of Apollo and Marsyas and the tale of Argus and Mercury,[1] are beautiful, lively and effortless, as are the attitudes adopted by the figures therein: these you, so young, have painted to my great satisfaction and indeed to everybody else's, for the ceiling of my house, in less time than normally might have been devoted to the mere consideration of the subject. Often one finds that haste and imperfection go together, so that it is an especial pleasure to find speed in execution accompanied by excellence. Certainly the brevity of the execution depends upon knowing exactly what one is doing; so that one sees, in the mind's eye, exactly where to place the light colours and where the dark. Because of this total understanding, the naked and clothed figures emerge almost as of their own accord, with their proper emphasis. My son, now that your brush bears witness with the present works to the

1. *Contest of Apollo and Marsyas,* 1544-45, Wadsworth Athenaeum Museum of Art, Hartford, ill. opposite; and *Mercury and Argus*, 1544-45, lost.

fame that future ones are bound to acquire for you, let no time pass before you thank God, the goodness of whose mercies inclines your soul to the study of righteousness no less than to that of painting. For you well know that the former can exist without the latter, but the latter cannot exist without the former. Philosophy and theology are arts, and arms, and the art of war too is a craft. And as one sort of timber is good for masts, one for oars and one for the hulls of ships, and this serves better than that for beams or stairs; so this talent, which varies in excellence in everyone throughout the professions, allows you to soar above this one in paintings and allows that one to surpass you in working marble. But in the profession of goodness, keenness of intelligence and industry of hand play no part; since it alone involves virtue not of hand or mind, but of the soul or spirit, which is not given to us by nature, but breathed into us by Christ.

VENICE, APRIL 1548

To Jacopo Tintore

Since the voice of public praise accords with the opin-
ion I myself gave you on the great painting of the
Saint in the Scuola di San Marco,[1] I am no less de-
lighted with my judgment, which sees so deeply, than
with your art, which is so superlative. And just as there
is no nose, however incapacitated, which does not get
a faint scent of the smoke of incense, similarly there is
no man so little instructed in the virtue of design that
he would not marvel at the relief of the figure who,
quite naked on the ground, lies open to the cruelties
of his martyrdom. The colours are flesh, indeed, the
lines rounded and the body so lifelike that I swear to
you, on the goodwill I bear you, that the faces, airs
and expressions of the crowd surrounding it are so
exactly as they would be in reality, that the spectacle
seems rather real than simulated. But do not indulge
in pride, if this is the case, because that would be tan-
tamount to turning your back upon the attainment of

1. *Miracle of the Slave*, 1548, Venice, Accademia; ill. overleaf

Overleaf: Miracle of the Slave, 1548

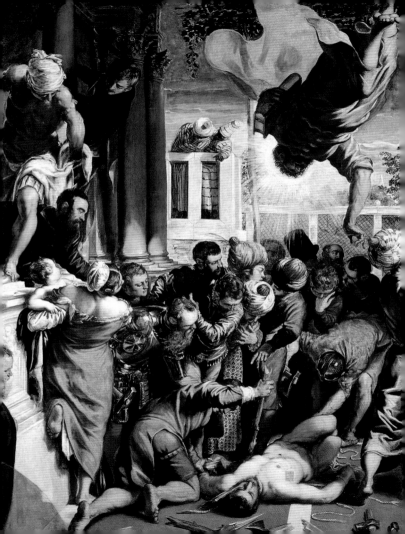

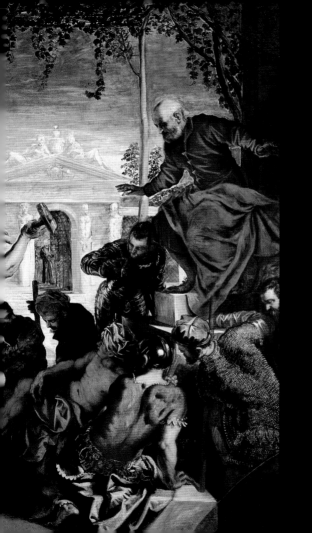

seems rather real than simulated. But do not indulge in pride, if this is the case, because that would be tantamount to turning your back upon the attainment of an even higher degree of perfection. And blessings be upon your name, if you can temper haste [*prestezza*] to have done with patience in the doing. Though, gradually, time will take care of this; since time, and nothing else, is sufficient to brake the headlong course of carelessness, so prevalent in eager, heedless youth.

Andrea Calmo

Further delightful and ingenious letters

from

*Calmo to Messer Giacomo Tintoretto the
Painter, the Favourite of Nature,
Commixture of Æsculapius,
and Stepson of Apelles*

1548

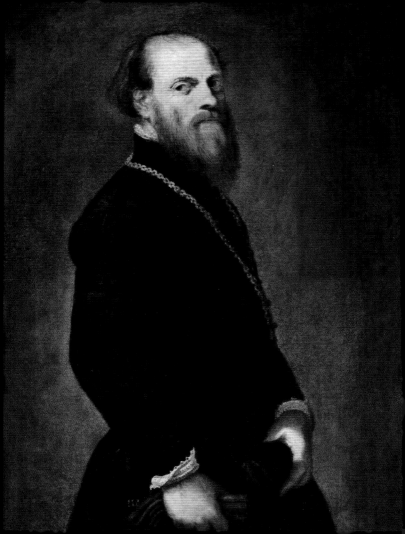

Just as a single peppercorn can mix with, over-power and oust ten bunches of poppies, thus precisely and exactly do you, kinsman of the Muses, to other artists; and you should be glad that, young as you are, you have been endowed with great verve, a light beard, a profound intellect, a small body but great spirit, though young in years, old in judgment, and, in the short time that you were a student, you learned more than a hundred who are born masters.

I do not know how to train my mouth to sing your praises adequately. How there could be so much in-telligence in a small man's body remains as much a mystery to me as a crocodile in the fourth clime. Let's accept that some people believe that potters can per-form miracles, because, by moving a foot and making a hollow with a hand, they suddenly turn a lump of clay into a crock, a vase or a bowl; yet look at it: it is just some earth and shall turn again unto dust; but you, twiddling with your paintbrush and a small dash of white lead, and mixing some red earth [*ambuoro*],*

* *Ambuoro* (or arcanna, or arcanea) is a type of red earth with which shipwrights dyed ropes; then, they applied those ropes to mark the cut to be sawn along the timber.

Opposite: Gentleman with a Gold Chain, c. 1555

61

you create a figure portrayed from Nature in half a hour, whereas you could not find a cobbler, tailor, or mason out there who in twenty years could even learn how to grind the pigments. I also knew that you had so fine a conception for presenting gestures, postures, front-faces, foreshortenings, profiles, shadows, distant views and perspectives as anyone riding the modern Pegasus; and it would be very fair to say this truth, that if you had as many hands as you have spirit and knowledge, there wouldn't be a difficult thing that exists in Nature that you couldn't create.

I am fond of you, my brother, by the blood of the paltry gnat, because you are an enemy of idleness and spend your hours partly to the benefit of your honour, partly restoring your body and partly consoling your spirits, that is, working to obtain profit and glory, eating to live and not shooting the breeze, and playing, laughing and singing to not lose your mind, as happens to so many people, who become so obsessed with their creations that they then lose their intellect and inspiration at a single blow. My cousin of fancy pile-on-pile velvet, I thank God for all the blessings you have, because you may be sure that as your life proceeds, as all of your friends hope, your name is destined to echo throughout every part of the world, as far as the discovered Indies and below

the Antipodes, then moving off toward the skies, to leave memories in the abodes of the seven planets, and descending into the deepest abyss to show to all that the ancient masters made nothing but doodles in comparison with us, and to leave the imprint of your greatness so deeply engraved on Pluto's judgment seat. Finally, apart from the fame of the works done for your own delight, there are no riches that can pay you, nor language capable of exalting you, nor man to compare with you and, to make the meal complete by adding the sweetmeat, you are courtesy, love, and charity itself, and give me as much satisfaction by pleasing everyone and making the miserly, the wicked and the envious explode, as though you had given me a bucket of soft shell crabs — which I really need to go and catch some sea bream, all the more now because the tide is just right.

Stay a close friend to me though; note that I swear to you, on the body of the grey mullets, that you might not have a stronger backbone than I, both for your genteel qualities, and also because my flour holds its own with your yeast. May God guard you from those who laugh and avert their eyes, those who swallow their own phlegm, and those who eat with you and keep silent. Think of me when you have a spare moment, urging yourself to keep the promises

that so easily come from your mouth and soon slip from your mind, so as to avoid the reputation of a humbug.

Veronica Franco

Letters

from

**Familiar letters to various people by
Signora Veronica Franco**

1580

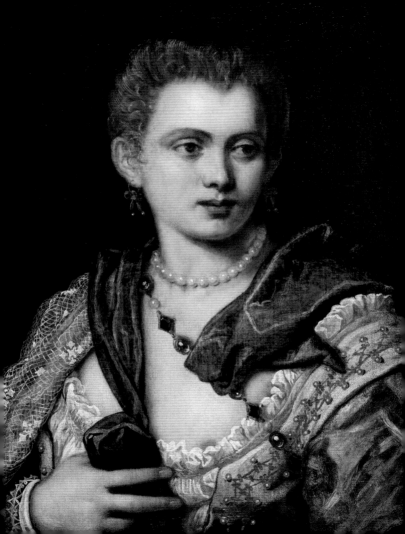

I cannot, Signor Tintoretto, bear to listen to certain people who on occasion will praise ancient times so much and find fault with our own. People who would claim that to those of olden days Nature was a most tender mother, while to our contemporaries she is a very cruel stepmother indeed; how this may be far from true can be judged by those who have judgment and no animosity, as it seems to me such people do. Among the other things that cause them to praise the ancients to the skies, they include the fairest and most noble art of painting, sculpting, and working in relief, and based on I do not know what, they declare that nowhere in the world is there to be found anyone who attains the excellence of Apelles, Zeuxis, Apollodorus, Phydias, Praxiteles, and other noble and famous painters and sculptors of those days.

I have heard it said by honourable gentlemen well-versed in antiquity, and with the greatest judgment in this art, that there are painters and sculptors of our own times, and alive today, who not only equal the ancients but must be put before them, like Michelangelo, Raphael, Titian, and others, and now you. I

Opposite: Possibly Domenico Tintoretto after Jacopo Tintoretto, Portrait of a Lady (Veronica Franco?), c. 1580

67

do not say this to flatter you, you see, because this is bruited about; and if this appears to you not to be the case it is because you lock your ears to praise, and do not care to know what opinion people have of you, as they are wont to do with those of your art, or of any other. I think this comes about because having reached the summit of that art, and knowing that no one else has gone that far, like those who disdain having as a guide someone who has not walked that way before, you do not heed the judgment of others, whatever praise or blame it brings you, and remain wholly intent on imitating, nay surpassing Nature, in as many ways as possible, and not only in those parts in which she is truly imitable, as in creating nude or clothed figures, and providing them with colours, shadows, profiles, lineaments, muscles, movement, actions, stances, inclinations, and postures conforming to Nature; but also in expressing the emotions of the soul in such a way that I do not believe even Roscius* could have simulated them on stage as well as your miraculous and immortal paintbrush can paint them on panel, wall, canvas, or any other support.

* The celebrated Roman actor Quintus Roscius Gallus, a contemporary of Cicero

Opposite: Danaë (with workshop assistance), c. 1580

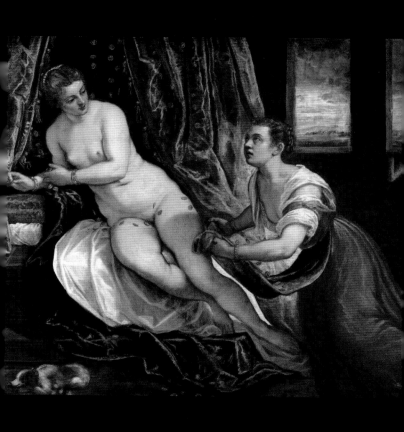

I promise you that when I saw my portrait,[1] the work of your divine hand, for quite some time I remained in doubt as to whether it was a painting or an apparition brought before me by some diabolical deceit. It was not certainly in order for me to fall in love with myself, as happened to Narcissus, because, thank God, I do not hold myself to be so lovely as to fear losing my mind over my own loveliness; but it was for some other reason that I do not know. Whence I can tell you, and you should hold this to be true, that now that sublimely bountiful Nature has seen how easily you can imitate her, nay surpass her (because the more your honour is increased by your immortal works, the more hers is eroded), she will never dare give the men of our time such high and uncommon intellect as fully to enable them to grasp the excellence of your art, because she would be shamed both in word and in deed, throughout all the ages to come. And I, certain of not succeeding in such a feat, here lay down my pen; and I pray God grant you happiness.

1. Possibly similar to Domenico Tintoretto after Jacopo Tintoretto, *Portrait of a Lady* (Veronica Franco?), 1580s, Worcester, Massachusetts, Worcester Art Museum, ill. p. 66

Carlo Ridolfi

Life of Tintoretto:

from
The Marvels of Art

1648

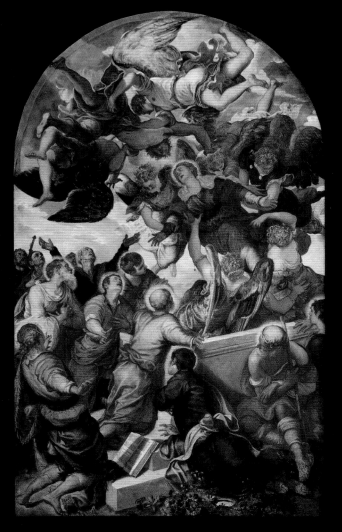

One ought not, as some think, esteem that picture which is embellished with a rich display of colours, since the difficulty in painting does not lie in knowing how to lay out vermilion or ultramarine on panel or on canvas. Still less does the painter acquire the title of learned by weaving gems and ribbons in hair, or by embroidering silk cloth with arabesques. Nor does the perfection of so sublime an art end with the imitation of flowers, plants, and animals, since in pictorial compositions such things serve only to provide an element of decoration and do not constitute the essential beauty of painting.

I, for my part, based on a clearer understanding of the matter, would say that all unreasoning plants and animals have certain pleasing forms, and may evince a certain superiority because of special qualities they may have or because of some more or less evident beauty. Yet they cannot be praised for possessing the highest perfection of form in comparison to man. To man was given greater beauty and dignity and a harmonious symmetry, bringing him to a level of grace and decorum which (besides the possession of the most excellent proportions that are among inferior

Opposite: Assumption of the Virgin, c. 1560-65

creatures diffused, and the faculty of reason, which is man's gift alone) render him superior to all created things.

Nor do these conditions make up the whole of his nobility, since as the preferred creature he had his being from the hand of the Eternal Creator, whereas the others were created with only a gesture of His omnipotence. But it pleased God to shape man out of clay, forming from it the skeletal framework, connecting it to the nerves, adding muscles, arteries, cartilage, veins, and the most delicate skin. Then He raised the forehead, formed the nose, opened the mouth, lowered the chin, carved out the ears, separated the hairs, curved the shoulders, broadened the chest, extended the arms, modelled the hands, drew out the flanks, made the thighs muscular, the legs sinewy, and placed them on the very strong base that is formed by the feet. And as the Supreme Painter, He dipped his brush in the whiteness of the lilies, the vermilion of the roses, and tinted the cheeks and the soft lips and all the rest of the body.

Nor did He here end His marvels, since by infusing in man the faculty of the intellect He made him an image of Himself, bringing him in such guise to the height of perfection. But since it was our intention to speak only of the visible forms, leaving aside the

beauties within, it will suffice us to have shown how the human body, through the order of its creation and through the beauty of its parts, surpasses in nobility everything in the universe. Whence one may without difficulty conclude that if, in the ordering of Nature, God did not make anything more beautiful or better than man, then the most excellent operation that can come from a diligent hand will be brought into being if he knows how to form the human body with just proportions, with gracious movements, and rare emotions. It is then that the painter will, without doubt, reach the most difficult aspect of his art. Thus it will be our concern, however difficult the undertaking may be, to tell of the doings of the great Tintoretto, and through our narrative to make his works known, to tell how he reached the arduous apex of art; and how with his brush he brought to the images that he painted the greatest state of perfection and how he adorned painting with the most novel and rare inventions, so that nature, which at times is defective, obtained through his hands grace and grandeur.

But before we become immersed in the sea of his many labours (through which anyone, however undiscerning, will clearly see that those things that we are setting out to describe are not exaggerated) let us speak of his birth and education.

Jacopo was born in Venice, the theatre of all marvels, in the year 1512.* His father was Battista Robusti, a Venetian citizen, and a cloth dyer, from which the boy took the surname of Tintoretto [the little dyer]. As a child Tintoretto began to draw on the walls with charcoal and the colours of his father's dyes, tracing childish figures which nevertheless had about them some element of grace. His parents on seeing them deemed that it would be well that he cultivate his natural inclination, and so they placed him with Titian. While he was living with the other youngsters in Titian's house he managed to copy some of his works.

Not many days later Titian, returning home, entered the room where the students were, and on seeing some papers at the bottom of a bench with certain figures drawn on them, asked who had done them. Jacopo, who had made them, fearing to have done them incorrectly, timidly said they were his. But Titian foresaw that from these beginnings the boy might become a man of great merit. Scarcely had he climbed the stairs and laid aside his mantle than he impatiently called his pupil Girolamo [Girolamo di Tiziano] (thus does the worm of jealousy affect the

* In fact 1518 or 1519

Opposite: Studies of a Statuette of Atlas and a Figure Praying, 1549

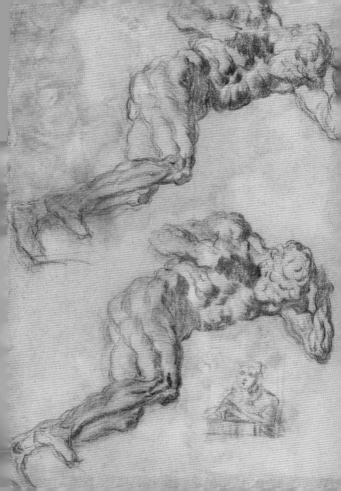

human heart) and ordered him to send Jacopo from the house as soon as possible. And so, without knowing why, Tintoretto was left without a master.

We can imagine the vexation he must have felt. But since it happens that such affronts sometimes become a spur to noble spirits and give rise to great resolutions, Jacopo, moved by noble indignation, gave thought, even though he was still a child, on how to bring to conclusion the undertaking he had begun. Nor did he allow his emotions to gain the upper hand, recognising the merit of Titian who was praised far and wide. In any case he thought he could become a painter by studying the canvases of Titian and the reliefs of Michelangelo Buonarroti, who was recognised as the father of design. Thus with the guidance of these two divine lights who have made painting and sculpture so illustrious in modern times, he started out toward his longed-for goal, furnished only with good counsel, to point the way on his difficult journey. So as not to stray from his proposed aim he inscribed on the walls of one of his rooms the following work rule:

MICHELANGELO'S DRAFTSMANSHIP
AND TITIAN'S ART OF COLOURING

Next he set out to gather from many places, and

with quite an outlay of money, plaster models of antique marbles. He had brought from Florence the small models that Daniele da Volterra had copied from the Medici tomb figures in San Lorenzo, that is to say *Dawn, Dusk, Day,* and *Night.* These he studied intensively, making an infinite number of drawings of them by the light of an oil lamp, so that he could compose in a powerful and solidly modelled manner by means of those strong shadows cast by the lamp. Nor did he cease his continuous study of whatever hand or torso he had collected, reproducing them on coloured paper with charcoal and watercolour and highlighting them with chalk and white lead. Thus did he learn the forms requisite for his art.

Being of keen mind he knew well that it was necessary to make drawings from carefully selected pieces of sculptures and to avoid the strict imitation of Nature which usually gives imperfect results because Nature never succeeds in achieving equal beauty in all her parts. Tintoretto observed accurately that the best artists selected from Nature, improving on her defective parts, so as to achieve perfection. He continually copied Titian's pictures, and on them based his handling of colour, with the result that in the paintings of his maturity one can see the fruits of the careful observation of his years of study. Without allowing

his ardour to cool, by following in the footsteps of the best masters he reached perfection with rapid strides. He set himself, moreover, to draw the living model in all sorts of attitudes which he endowed with a grace of movement, drawing from them an endless variety of foreshortenings. Sometimes he dissected corpses in order to study the arrangement of the muscles, so as to combine his observation of sculpture with his study of Nature, taking from the first its formal beauty, and from the second, unity and delicacy.

He trained himself also by concocting in wax and clay small figures which he dressed in scraps of cloth, attentively studying the folds of the cloth on the outlines of the limbs. He also placed some of the figures in little houses and in perspective scenes made of wood and cardboard, and by means of little lamps he contrived for the windows he introduced therein lights and shadows.

He also hung some models by threads to the roof beams to study the appearance they made when seen from below, and to get the foreshortenings of figures for ceilings, creating by such methods bizarre effects.

On these foundations Tintoretto built the structure of his programme, since to start out well in any discipline is, as some say, to progress in the study of it:

THAT WORK WHICH IS WELL BEGUN, IS HALF DONE

He also contrived, in order to gain practice in using colours (since study without practice does not suffice), to be wherever painting was being done. And it is said because of his desire to work that he even went with some masons to Cittadella, where he painted certain fanciful effects around the face of the clock, so as to unburden his mind which was filled to the brim with countless ideas.[1]

He also practiced with painters of small success who decorated furniture for the painters in Piazza San Marco and this he did in order to learn their methods. He preferred, however, the painting of Schiavone, whom he willingly assisted without any recompense in order to learn that master's method of handling colours. Likewise he assisted him in Ca' Zen at the Crociferi where, in a corner at the top, he painted the figure of a reclining woman.[2] And after some time he painted on his own the Conversion of St Paul with many figures on the side toward the square, only traces of which remain.[3] And in those early years he painted for the Scuola dei Sartori, near the Crociferi, the Life of St Barbara, a pictorial cycle arranged in a frieze around the walls, and also the figure of a St Christopher, above the square, which is now completely gone.[4]

1. Undocumented 2. Undocumented 3. Destroyed 4. Destroyed

Also during that period, which one could say was the golden age of Venetian painting, many youths of fine intellect and replete with talent made progress in their art and competitively exhibited the fruits of their labour in the Merceria so as to find out the reaction of the viewers. And Tintoretto with his inventions and original ideas was also on hand to show the results that had been brought about in him by God and Nature. Among the works he exhibited were two portraits, one of himself holding a piece of sculpture and one of his brother playing the lyre,[1] both night scenes, which were depicted in so formidable a manner that he astonished everyone. Whence a noble spirit inspired by that vision to express himself in poetry wrote thus:

> IF TINTORET'S LIGHT AT NIGHT APPEARS SO FINE
> HOW SHALL HIS RADIANCE IN DAYLIGHT SHINE?

He also placed a narrative painting with many figures in the Rialto.[2] As soon as he got word of it Titian hurried over to see it and was unable to restrain his praises though the old rancour toward his despised pupil still remained. The power of talent is such that it draws praise from envy itself, which can do no less than celebrate that merit which sometimes appears in the enemy.

1. Unidentified 2. Unidentified

But let us briefly note those things that he did in the spring of his years, those first shoots from which will come the fruits of his maturity. Since at that time in Venice the only works that were praised were those by Palma Vecchio, Pordenone, Bonifacio and, especially, Titian, who usually got the most important commissions, there was no way for Tintoretto to make his true worth known and gain public esteem except by working on public commissions with subject matter of greater import. Thus in order to overcome those difficulties which commonly impede unknown beginners he undertook all sorts of laborious tasks. There is no path more difficult to follow than that of virtue, strewn as it is with stones and thorns; and at the end the prize for such noble effort is approbation, which does not nourish and quickly fades away.

Among the things that Tintoretto undertook to paint were the organ shutters of the church of Santa Maria dei Servi, on which he depicted large figures of St Augustine and St Paul and on the inside part the Virgin Annunciate, and below Cain killing Abel in fresco; and on the sides of an old altar in the chapel opposite he painted Our Lady Annunciate with the angel.[1]

1. All untraced

In the church of the Maddalena above the cornice
he placed a painting of the preaching of Christ with
the penitent Magdalen. And afterwards in another
work he painted the Magdalen on her deathbed re-
ceiving communion from St Maximinus. In the
Maddalena there are also portraits of priests of that
church and a kneeling servant in a graceful pose hold-
ing a torch and stretching out an arm to support the
Magdalene.[1]

In the church of San Benedetto he painted an al-
tarpiece with the Virgin and several saints for the high
altar.[2] In another altarpiece he painted the Birth of
the Saviour.[3] He also painted on the organ the Virgin
Annunciate,[4] and the Woman of Samaria at the Well.[5]
But when the church was restored the paintings were
removed and only some of them have been put back.

Afterwards in the church of Sant'Anna he painted
a picture of the Tiburtine Sibyl pointing out to the
Emperor Octavian Augustus the Virgin with the In-
fant Jesus who appears in a nimbus of glory within

1. All untraced 2. 1563, with workshop assistance, Modena, Galleria
Estense 3. Untraced 4. *Angel of the Annunciation* and *Virgin
Annunciate*, *c.*1560, Amsterdam, Rijksmuseum; ill. pp. 262-63
5. *Christ* (fragment) *and Samaritan Woman*, with workshop assistance,
*c.*1560, Florence, Uffizi

which a portrait is included; it is now placed on the altar of the nearby *scuola*.[1] And in the church of Spirito Santo he painted a small altarpiece of the Adoration of the Magi.[2] In the church of the Carmini [Santa Maria del Carmelo], he painted the Circumcision[3] which many believe to be by Schiavone because Tintoretto sometimes adopted that style.

About the year 1546 he painted in fresco the façade of the Ca' dei Fabbri at the Arsenale. There he depicted the Feast of Belshazzar with the king and his followers at the table drinking from the sacred vessels and the finger writing on the wall *Mene, Mene, Tekel, Upharsin*, the words which foretold the division of that kingdom.[4] It was that work which gave everyone the idea that in the field of art he would be a marvel.

Afterwards, as he grew in valour, he painted pictures that were more profound and erudite, such as the two pictures in the church of San Marcuola [Santi Ermagora e Fortunato] of the Last Supper[5] and the Washing of the Feet of the Disciples[6] with beautiful

1. *Emperor Octavian Augustus and the Tiburtine Sibyl*, possibly by a northern follower of Tintoretto, *c.*1580s, unknown 2. Untraced
3. *Presentation of Christ in the Temple*, *c.*1546-48, in situ, ill. pp.150-51
4. Destroyed 5. 1547, in situ 6. *Christ Washing the Feet of the Disciples* 1548-49, Madrid, Prado, ill. overleaf

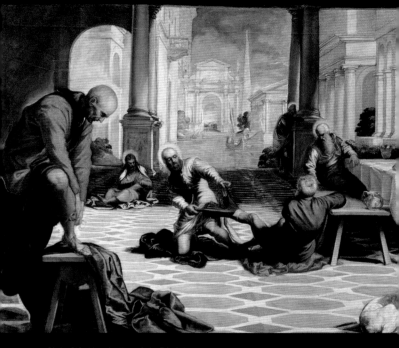

Christ Washing the Feet of the Disciples, 1548-49

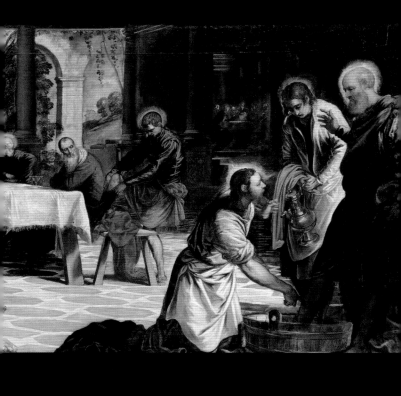

perspective views; the latter however was removed and replaced by a copy.

In the church of San Severo he painted on a long canvas the Crucifixion of the Saviour,[1] placing therein a quantity of figures engaged in various activities. The Virgin is with the three Maries at the foot of the Cross, and there too are the soldiers who cast lots for the garments, who are in very natural positions, revealing a skillful sense of the structure of muscles in the areas where the body is unclothed. He made use of delicate and soft colours and exhibited a mastery of form from which we can comprehend how useful had been his study of the works of Titian and Michelangelo. It thus follows that Tintoretto is worthy of great praise since he knew how to avail himself of what he had studied and how to adapt it to his own use, thus forming a style that was skilful and overflowing with beauty, because of which he was admired and revered by the masters of his profession.

Later in the Scuola della Trinità he did five paintings of the creation of the world. And among them is the very celebrated scene in which he painted the error of our earliest forebears when, persuaded by

1. *c.* 1557, Venice, Accademia

the Serpent, they eat the forbidden fruit;[1] and that of Cain killing his brother.[2] In the others he painted the creation of the fishes, the animals,[3] and Eve.[4]

Tintoretto used to say when talking about those paintings that he drew the body with great diligence from life, putting over his models a string gridwork so he could observe precisely the various parts of the limbs. He increased to some extent the beauty of the outlines, however, as he had learned to do from his study of sculpture, without which emphasis figures are little appreciated. And in those nudes he used to say he wanted to demonstrate the way that must be employed in making life drawings. Those bodies would never have been brought to such a rare beauty if he had not supplemented that which Nature lacked. The good painter must, he made clear, increase the beauty of Nature with his art.

It was still the custom in that city of Venice, as we have noted, to decorate the houses with frescoes,

1. *Temptation of Adam and Eve*, 1550-53; Venice, Accademia 2. *Cain Killing Abel*, 1550-53, Venice, Accademia 3. *Creation of the Animals*, 1550-53; Venice, Accademia, ill. overleaf 4. Destroyed. The fifth painting was *Adam and Eve Before God*, 1550-53, of which a fragment survives, Florence, Uffizi

Overleaf: Creation of the Animals, 1550-53

some of which are still preserved, for which those families deserve praise. Since a house, Ca' Soranzo dell'Angelo, was being built at the Ponte del Remedio, it seemed to Tintoretto to present an opportunity to demonstrate his ideas. Talking it over with the masons, to whom was often given (as we touched upon in the *Life* of Schiavone) the charge of engaging the painter, he was told that the owners did not want to spend anything on it. But he, who, in any case, was determined to paint it, decided to do it for the cost of the colours alone. When that was reported to the owners they with some further difficulty agreed. Thus does unhappy virtue find no resting place.

Having obtained the commission, he wanted to give full play to his talent. In the lower section he painted a battle of knights mounted on raging horses. Across the façade ran a cornice held up by simulated bronze hands and feet.[1] Above this he painted a historical scene and a frieze with many figures; and on the top between the windows he represented several women arranged in beautiful attitudes, in each part demonstrating the skill and liveliness of his genius, so that even the painters themselves were amazed.[2]

1. *c.* 1540-45; fragments survive, Venice, private collection. Engraved by Anton Maria Zanetti (1760) 2. Untraced

A similar caprice came to his mind while painting the small house of a dyer at the bridge of San Giovanni Laterano. There he represented a nude Ganymede being carried off by Jove, who had assumed the guise of an eagle.[1] Nor did he here consider representing a soft and delicate youth as described by the poets' pens, but only to express the condition of a muscular boy full of feeling, and he painted him in such a way that he could not be painted more boldly.

And since his fertile genius bubbled continuously with ideas, he was always thinking of ways to make himself known as the most daring painter in the world. So he proposed to the fathers of the church of the Madonna dell'Orto to paint two large pictures for the chapel of the high altar, which was fifty feet high.[2] The Prior, deeming that a year's revenue would not be sufficient for such an undertaking, laughingly dismissed him. But Tintoretto, without losing his poise, added that he asked for this work only enough payment to cover his expenses, and that he wished to make them a gift of his labour. The wise Prior, on thinking it over, decided not to let such a fine opportunity slip by and so he concluded an agreement with him for one hundred ducats.

1. Untraced 2. In fact 14.5 m, which is *c.* 42 Venetian feet

When the report of this agreement was spread about it gave the established painters grounds for jeering, seeing the manner in which Tintoretto appropriated the most conspicuous commission in the city, though he had no current testimonials affirming his ability; when art is reduced to such terms it is harmed not a little.

There is no doubt that every profession is enhanced by decorum and reputation, and this is true in particular of painting. Nor is it likely that the works of any painter, though they may be excellent, can attain the level of the sublime if they are debased by their author. Applause converges on the finest outward show, and the world deems the height of perfection to be found where the treasures are most lavish, since it is our nature to be tyrannized by desire. But Tintoretto did not know how to profit from this practice. As a result the ground he sowed with great labour yielded but a small harvest, though by right it should have brought him comfort and fortune.

But he gave little heed to the painters' complaints since his efforts had no goal other than satisfaction and glory which, though devoid of profit, is worthy of praise. Now let us go on to speak of his paintings. In one he represents the detestable deed of the Hebrews, who, in return for favours received from the

lavish hand of God, set up as an idol the Golden Calf[1]
(the sin of idolatry may be said to be more detestable
than any other since it amounts to the denial of God
Himself). In full view of the people and with solemn
pomp the Hebrews carry the idol on a platform fur-
nished with handles and adorned with gems, and
following it is a festive group of men and women car-
rying branches and cymbals. Among those in the fore-
front is a woman dressed in blue who points out the
idol to the others. The grace and skill of this figure are
indescribable. In one corner stand some aged crafts-
men with the square and compass in hand, pointing
to the idol they have made. On the steep slope of a
nearby mountain we see countless women who as a
sign of joy have hung lengths of silk on the mountain
and who strip from their necks and ears pendants
and jewels to give to what they believe to be a de-
ity. Meanwhile on another high precipice encircled
by dark clouds is Moses receiving the laws from God,
who is sustained by a group of nude angels arranged
in graceful and elegant attitudes.

I will forego describing the order of the composi-
tion, the study, the energy, and drawing put into the
limbs of the bearers, for such abundant and erudite

1. *The Making of the Golden Calf, c.* 1559-60; in situ; ill. p. 38

inventions cannot be restricted to a few words, nor can one believe that the author in undertaking such an enterprise was activated only by a desire for glory.

In the other painting Tintoretto represented the Last Judgment[1] which captures the terror and fright of that last day. At the top is Christ the Judge, with the Virgin and St John kneeling before him, plus the Good Thief with his cross on his shoulder, and facing him the Theological Virtues, which are means of shielding oneself from divine wrath. The saints are seated on the many circles of clouds, in the midst of which angels descend blowing the trumpets to wake the dead to judgment. On the left side is a mass of men and women who fall headlong, driven out by St Michael's gleaming sword. And since Tintoretto also wished to show the resurrection of those whose grave was in the waters, with extraordinary originality he painted a far-off river full of bodies flung about on its waves. There too he represented Charon's bark filled with the damned, who are being taken off to Hell by demons who look like wild beasts and horrible monsters. And as he wanted to show the resurrection of

1. *c.* 1559-60, in situ; ill. pp. 23, opposite, and on p. 98

Opposite: The Last Judgment (detail of upper half), c. 1559-60

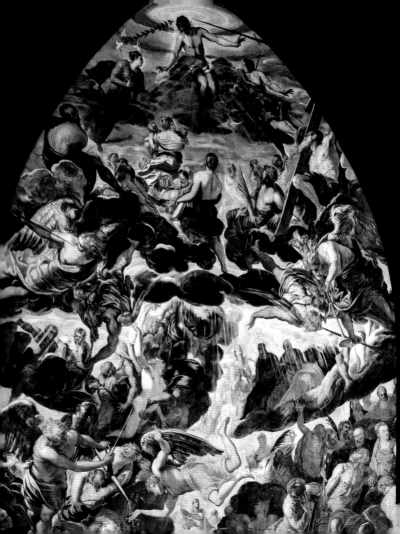

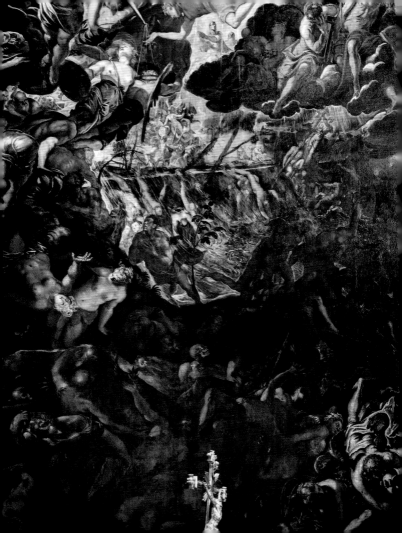

bodies in a natural way, he painted some in the foreground that had already taken on flesh. Others with skulls for heads, and from whose arms sprout leafy branches, are rising up from the earth; others spring up violently from their sepulchres, and many others, jumbled together with demons, fall into the abyss.

Here the pen can only give a faint idea of such an extravagant and abundant invention, since to describe the countless poses of those figures, the power of the bodies, the art employed in the rushing of the river, and the many learned observations that appear would exhaust the talent of any bold writer. Works that are prodigious may in some way be indicated by the pen, although they cannot be fully described.

On the outside of the organ wings he then painted Our Lady as a child who majestically climbs the steps of the temple where at the top the priest stands to receive her.[1] And on the steps he arranged many figures that gradually become smaller as the stairs recede. At the bottom is a woman standing with her back turned, pointing out the Virgin to her daughter. Her movement and grace are beyond description. On the inner

1. *Presentation of the Virgin in the Temple*, c. 1556; in situ; ill. pp. 42–43

Opposite: The Last Judgment (detail of lower half), c. 1559–60

part of the organ wings he painted four flying angels carrying the Cross to St Peter, who is seated and wears pontifical robes.[1] On the other wing is the kneeling St Christopher awaiting the blow of the executioner's sword.[2] Pieces of armour are on the ground and a very joyful angel with palm in hand descends from the sky. These events, and the artistic elements with which they are adorned, were beautifully painted by Tintoretto.

Next, in the chapel of Cardinal Gasparo Contarini, he painted the altarpiece of St Agnes[3] who, accompanied by a group of noblewomen of comely visage and elegantly clothed, brings back to life by her prayers the prefect's son who fell dead when he wanted to do her violence. Here we admire the perfection of Christianity, which for injuries received returns acts of mercy. The composition is enriched by distant views of colonnades and angels who witness the miracle.

But let us go on to discuss works that are still more complex. With the opportunity afforded by the many excellent painters who then flourished in Venice, the

1. *Apparition of the Cross to St Peter, c.*1556; in situ 2. *Beheading of St Paul, c.*1556; in situ. Incorrectly identified by Ridolfi 3. *St Agnes Cures Licinius, c.*1565-70; with workshop assistance, in situ

churches and the chambers of the confraternities were adorned by new paintings, works which improved on the crude old-fashioned manner of painting that was used by painters of the past, whose work does little to please the eye. It happened that some of the administrators of the Confraternity of San Marco met with Tintoretto and commissioned him to do a painting about twenty feet square of a miracle of St Mark.[1] The subject deals with a servant of a knight of Provence who against his master's will departed to visit the relics of St Mark. On his return the knight commanded that in expiation for his transgression his eyes should be put out and his legs broken.

Here, then, Tintoretto painted the servant amid broken pieces of iron and wood prepared for the torture; and in the air we see, brilliantly foreshortened, St Mark coming to his aid, and he remained unharmed since the saints do not fail to protect in their tribulations those devoted to them. Bearing witness to this great miracle are many people dressed in robes with barbaric ornaments, and also soldiers and functionaries in attitudes of amazement. One of them shows the hammers and splintered wood to his lord who is

1. *Miracle of the Slave*, 1548, Venice, Accademia; ill. pp. 56-57. See also Aretino's letter of April 1548, p. 55

seated above, overcome with wonderment. There are also some people clinging to columns, and among the marvels of that marvellous composition is a woman leaning against a pedestal and bending back in order to see the action, who is so alert and vivacious that she seems alive.

For this incomparable picture it suffices to have lightly sketched in the concept, since Fame with ever-lasting acclamation unceasingly spreads its honours, and every learned and perceptive person that comes to see it affirms that here are reached the outward limits of the art.

But since virtue always encounters difficulties it came about that differences of opinion arose among the members of the confraternity, with some wanting the painting to remain on display and others not. Hence Tintoretto became angry and had the picture taken away and brought back to his house. Finally the uproar died down, and the adversaries, seeing themselves jeered, and realizing how much they were giving up through the loss of that painting, which was universally acclaimed as a marvel, were forced to ask him to bring it back. And in the end, after keeping them in suspense for some time he replaced it. They

Opposite: Miracle of the Slave (detail), 1548

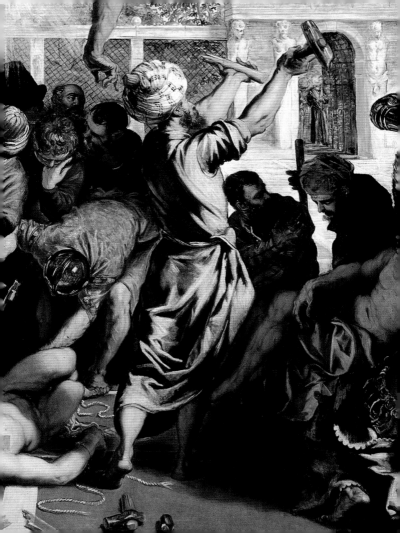

then assuaged his anger by commissioning him to do three more paintings for their rooms, and these he completed in the following way.

In the painting in the first room the scene is set in Alexandria. There we see the Removal of the Body of St Mark[1] which Buono da Malamocco and Rustico da Torcello, Venetian merchants, had obtained from Greek priests. In a long colonnade we see lining the wall many sarcophagi in excellent perspective, from which many bodies are being lifted. On the ground is the body of St Mark arranged in such a position that it follows the eye wherever it turns. Tintoretto has moreover, ingeniously represented in the painting a man possessed, in whom we see the frenzy that the Devil causes in humans, as often happens when saints' bodies are moved.

In the second picture the body of the saint is carried by the said merchants to the ships.[2] In the distance dark clouds descend with lightning and driving rain, and the spirit of St Mark in the form of a cloud leads the way. From it the frightened Alexandrians, aroused by the perfume strewn in order to prevent

1. *Finding of the Body of St Mark*, c.1564, Milan, Brera, ill. opposite
2. *Theft of the Body of St Mark*, c.1564, Venice, Accademia, ill. p. 107

Opposite: Finding of the Body of St Mark, c. 1564

the discovery of the body, flee into the nearby colonnades. One of them, who is half naked, tries to conceal himself in his mantle. In the meantime the pious porters have an opportunity to bring safely to the ships their acquired treasure.

The third painting is of a storm at sea when St Mark saved a Saracen from the waves.[1] The Saracen, along with other infidels, was travelling to Alexandria when the ship was wrecked by the fury of the winds: he invokes the name of the Saint, who transports him to the skiff where the Venetian merchants had taken refuge. We see that small craft buffeted by the tempest and the terror of the shipwrecked sailors who pull the oars, fearing all was lost. By that trust the Saracen was rescued from the perils of the sea, for faith has such power that even barbarian breasts are filled which the grace of God. Nor could another brush with greater skill reveal the mood of such a miracle, marvellously magnified by his author. And among the sailors he painted the celebrated philosopher Tommaso Rangone da Ravenna, in the ducal dress of gold.

With the name of Tintoretto, now well-known, rendered illustrious by his many works, the Venetian

1. *St Mark Rescues a Saracen*, *c.*1564, Venice, Accademia, ill. p. 108

Opposite: Theft of the Body of St Mark, c. 1564

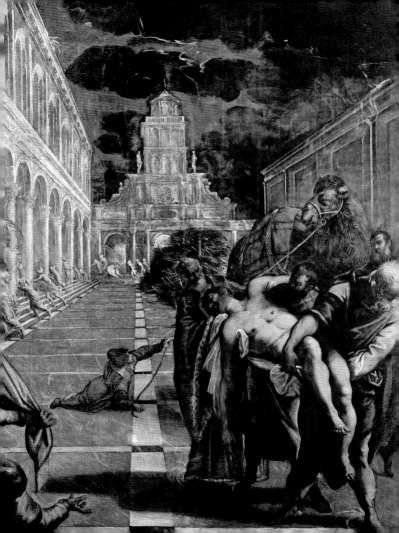

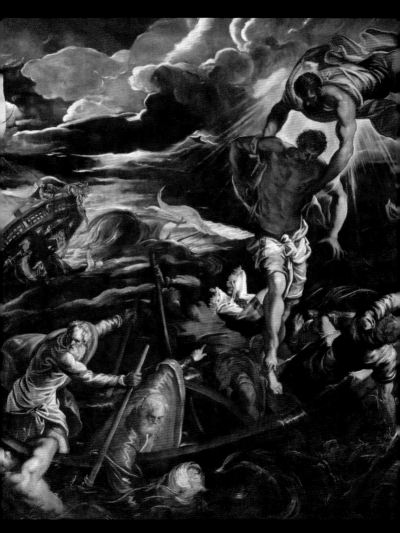

Senate wanted him to paint some works in the Hall of the Great Council. From time to time the old scenes that had been painted in an earlier age by Guariento, Gentile da Fabriano, Pisanello, Alvise Vivarini, and others, and which had been in part repainted by Giovanni Bellini, his brother Gentile, Titian, and other artists, were being redone.

He then was given the charge of painting the history of the Emperor Frederick Barbarossa receiving the imperial crown in Rome from the hands of Pope Adrian.[1] He represented therein with much decorum the papal court, with cardinals, bishops and Venetian senators, among whom were Stefano Tiepolo, Procurator of St Mark's, Daniele Barbaro, Giovanni Grimani, the Patriarch of Aquileia, and other noble Venetians. And underneath was the inscription:

POPE HADRIAN BESTOWED ON FREDERICK BARBAROSSA
THE INSIGNIA OF THE ROMAN EMPIRE IN ST PETER'S

And since a little later Paolo Veronese contributed a painting for the same hall, Tintoretto arranged it so that he too obtained another commission (for it

1. *Pope Adrian IV Crowning Emperor Frederick Barbarossa*, 1553, lost in a fire (1577)

Opposite: St Mark Rescues a Saracen, c. 1564

seemed to him that he had accomplished little in the previous work, which was the fourth from the entrance to the Hall of the Great Council). In this painting he represented Pope Alexander III with a number of cardinals and prelates in the act of excommunicating the Emperor.[1] He showed the horror and fear which such a malediction usually brings about in the bystanders. He painted the pontiff in the act of casting the extinguished candles among the crowd. And in order to give full rein to his fancy, for ordinary ideas did not satisfy him, he invented a scuffle among the common people who vie for the candles that were flung down among them. Every part of the painting he executed with the highest diligence and precision, so that it was proclaimed by everyone as something altogether extraordinary. Scattered throughout the canvas were portraits of Melchiorre Michiel, the Procurator of St Mark's, Michele Surian, and other illustrious personages whom, for the sake of brevity, we will not mention. And at the bottom of the scene we read:

POPE ALEXANDER, HAVING BECOME AWARE OF FREDERICK'S INSOLENT ACTS, BOTH PRESSED HIM IN SILENT WAR AND DROVE HIM AWAY WITH ANATHEMA. HIS DEEDS HAVING

1. *Pope Alexander III Excommunicating Emperor Frederick Barbarossa*, 1553; lost in a fire (1577)

BEEN PLACED UNDER ADVERSE EDICT, FREDERICK'S
KINGDOM WAS ALIENATED FROM POPE ALEXANDER

Then in the Voting Hall [Sala dello Scrutinio]
he painted the Last Judgment.[1] Christ the Judge is
in the centre borne by a group of nude angels and
flanked on either side by the inhabitants of Heaven.
The Elect, on the right, intermingled with angels, are
rising up to glory, while the Damned, on the left, are
pulled by furious demons down to Hell. In this sec-
tion he included a quantity of nude bodies skilfully
arranged in various poses. Such was the theme that
inspired the painting that struck terror in the hearts
of those who saw it. But this great work, together with
the other two paintings just mentioned, was destroyed
by a fire in the palace in 1577.

But let us go on to the church of San Rocco, where
Pordenone had frescoed the apse.[2] Tintoretto painted
two histories in oil there at the top of the walls, one of
the Conversion of St Paul[3] and the other of St Roch
visited by wild animals in the desert.[4] Then below he

1. Lost in a fire (1577) 2. 1528-29; painted over by Giuseppe Angeli
(1764-69) 3. *Capture of St Roch at the Battle of Montpellier*, with work-
shop assistance, incorrectly identified by Ridolfi; *c.*1585, in situ 4. *St
Roch Heals the Animals*, possibly with workshop assistance; 1567, in situ

added two other paintings, about twenty-four feet in length, which are of even greater perfection.

One of these shows St Roch in a hospital curing with the sign of the cross a plague-stricken man who lifts his leg to show his wound.[1] The rest of the hospital is filled with sick men and women. Some who have climbed up on the benches unbind their wounds. Others are seen weakly lying on the ground in poses so marvellously foreshortened that it appears that their feet are coming out of the canvas. Some old men are held up by youths, and women rise up from their beds to implore the saint's mercy.

This painting, which is celebrated for the originality of its composition, is worthy of all the praises that can be given to a work of the highest perfection. Each of its parts portrays a sadness so appropriate to the place that it arouses in men's hearts feelings of pity. The perfection of its design and the excellence of its colour are such that those bodies do not seem to be composed of oil paint, but formed of living flesh. Nor did envy ever find room for attack, since in the opinion of all who are well-informed in these matters there could not be anything more skilfully done.

1. *St Roch Cures the Plague Victims*, 1549, in situ, ill. pp. 36-37. See also El Greco's comment, p. 50

The other painting shows the saint stricken by the plague lying in bed where he is visited and consoled by a joyous angel dressed in the most lovely robes.[1] The arrangement of that composition is particularly worthy of commendation. In it are some chained madmen with wooden locks on their feet, and still others (besides the sick) who poke their heads out of the iron grilles set in the floor to whom the attendants bring food, the whole of which forms the most curious invention one might ever see. But since in their multiplicity and singularity Tintoretto's inventions are impossible to explain, we can excuse the defect of the pen that cannot fully represent them with its strokes.

In the middle of the church on the doors of a large cabinet (where the votive offerings of the devout are kept) Tintoretto painted (in competition with Pordenone, who painted a similar picture facing it) Christ commanding the paralytic to take up his bed and walk.[2] Nor is this a less precious painting than that aforementioned, since it is enriched by the grace that is brought to it by the artist, every stroke of whose brush adds to his immortality a bit of glory. And on

1. *St Roch in Prison Comforted by an Angel*, 1567, in situ, ill. overleaf
2. *Christ at the Pool of Bethesda*, 1559, in situ

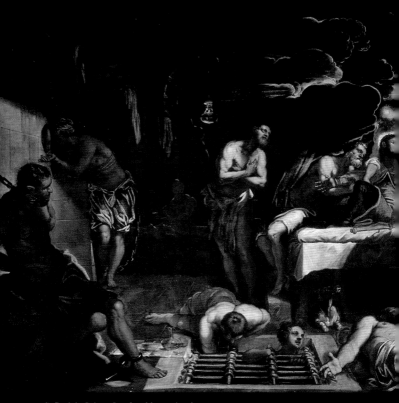

St Roch in Prison Comforted by an Angel, 1567

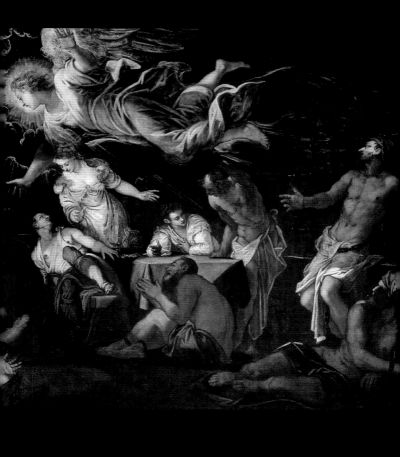

the doors of the organ he painted St Roch receiving the pope's benediction in Rome, and on the opposite side the Virgin Annunciate.[1]

Just about the same time, work began on the paintings of the vault of the library of St Mark's. Titian had from the procurators the charge of distributing the paintings amongst Schiavone, Paolo Veronese, Battista Zelotti, Giuseppe Salviati, Battista Franco, and other young men who were considered to be talented, but Tintoretto was excluded. Later, however, Tintoretto obtained from the procurators themselves the commission to paint some figures of philosophers on the walls. Among them is a seated nude, Diogenes,[2] who is painted so powerfully that he seems to stand out from his niche. It is in fact a stupendous figure, both in the quality of the body, which is drawn with the greatest care, and for the lifelike treatment of his pose. Diogenes is deep in thought, with his legs crossed and his chin on an arm that rests on his thigh. In this figure we sense the profound concentration of the philosopher. By the excellence of this painting Tintoretto avenged the wrong that Titian had done him and showed clearly how unfair he had been.

1. *St Roch Presented to Pope Urban V* and *Annunciation, c.* 1575-80, in situ
2. 1571-72, Venice, Libreria Marciana

But let us continue to speak of the paintings of the Scuola Grande di San Rocco. The seat of the confraternity, which was formerly located near the church of Santo Stefano, beyond the Grand Canal, was transferred in 1488 to a site near the church of the Frari. There with a lavish expenditure of funds a new seat was built on the plans of Jacopo Sansovino, Florentine architect and sculptor.

In about the year 1560 the members of the confraternity thought of acquiring an outstanding painting for the Sala dell'Albergo of their building. To this end they sought the best painters of the city, among them Tintoretto, to make a design for the central oval panel. But Tintoretto secretly obtained from the servants the measurements of the space, and while the others were working to make their designs he with admirable speed did the painting itself,[1] which depicts St Roch in glory received by God the Father and attendant angels who hold the attributes of his pilgrimage; and without a word to anyone he put it in place.

The day after, Paolo Veronese, Andrea Schiavone, Giuseppe Salviati, and Federico Zuccari were to appear to show their designs and Tintoretto was sought out to explain his as well; he had the painted canvas,

1. 1564, in situ; ill. p. 46

which had been skilfully hidden with cardboard, un-
covered, and said that this was the design he made,
about which there could be no error, and if his quick
work did not please them he would make a gift of it
to St Roch, from whom he had obtained many fa-
vours. The painters were dumbfounded to see such
a beautiful work carried out with such elegance in
the space of a few days. Gathering up their sketches,
they said to the members of the confraternity that
they could no longer have any claim to the commis-
sion, since Tintoretto through his valour had gained
the honour. Nevertheless, the members of the con-
fraternity were angry, and insisted that his painting
be removed because they had given no such order,
but only wanted to see a sketch of the composition in
order to give the work to the one that pleased them
most. But being constrained to keep it (being unable
because of their rules to refuse anything donated to
the Saint), and since it was in actual fact considered
excellent in the highest degree, and since, moreover,
the majority of the votes were in favour of Tintoret-
to, it was agreed that he should be worthily recom-
pensed. Receiving him into their order, they decreed
that he alone would be given the commission for the
rest of the paintings that would be needed for their
rooms. He was given an annual provision of one

hundred ducats for life, in return for which he was required to furnish one completed painting every year. But Tintoretto managed to dispatch them as quickly as possible, so that he drew his yearly pension for a long time after the paintings were completed (in his old age he used to say in jest that he wanted to live a thousand ducats longer). Then to complete the aforementioned ceiling he painted the insignias and habits of the six Scuole Grandi of the city, including that of San Rocco.[1]

He then went on to provide, within the space of the Albergo, the paintings of the principal events of the Passion of Christ. To the left of the entrance he placed a canvas which shows Christ before Pilate, wrapped in a cloth of linen.[2] With such grace and divinity is He endowed that we can believe we see God incarnate. But what makes that figure still more admirable is the delicacy with which Tintoretto arranged the convolutions of the drapery, and the gentleness he imparted to the movement of the limbs and the face in which he expressed the divine mercy of the Redeemer.

But here while we prepare to describe such an exceptional painting the hand hesitates, since no mortal

1. 1564, part of a set of sixteen allegories framing *St Roch in Glory*; in situ 2. 1566-67, in situ; ill. p. 26

pen is equal to so heavenly a concept. Above the door he painted the pitiable spectacle of the Saviour shown to the people by Pilate.[1] And in the right corner he is shown being led over the top of a mountain to Calvary, accompanied by a group of soldiers.[2] And with a fresh idea he added the two thieves with the crosses tied over their shoulders as they follow the exhausted Redeemer along the base of the mountain.

For the principal wall, in the place where the members sat during their meetings, he painted on a great canvas the Crucifixion,[3] wherein he related every important event narrated by the Evangelists. Here we see at the centre of Calvary the crucified Saviour. At the bottom the Virgin Mother, overcome with grief, collapses on the three Maries, who likewise are in agony, as St John and the Magdalen sorrowfully gaze at the cross. Meanwhile an attendant who has climbed a ladder that is leaning against the cross is immersing the sponge in vinegar and gall to increase with this bitter brew the pain of the thirsting Redeemer. In the left part some of the executioners furiously stretch out on one of the crosses one of the thieves who is nude. One grips the thief's

1. *Ecce Homo*, 1566-67, in situ 2. *Ascent to Calvary*, 1566-67, in situ
3. 1565, in situ; ill. pp. 122-24 and detail p. 125

hand in order to nail it, another drills the foot of the cross, while others provide the nails and gather up the rope. On the right we see the other thief, who is already crucified and is being lifted up by means of a long rope, through which Tintoretto expresses the muscular effort required by that action. Amongst the broken stones in the midst of the mountain are three soldiers who, having set aside their crossbows and spears, gamble over Christ's garments. Every part of Calvary is full of horror, of soldiers, and of government agents who have portioned out the tasks, and also groups of cavaliers on well-caparisoned horses. Lances, flags, and insignia of Roman rule surround the Mount. A multitude can be seen still coming out from Jerusalem, some on mules and some on foot, in order to see the spectacle of the hanging Saviour. To sum up, Tintoretto did not leave out anything that might be lifelike in that event, or that could arouse emotions of compassion in the onlooker as he beheld that tragic event. And, truly, in the representation of the mysteries of our sacred religion one should strive to reveal them so as to arouse devotion rather than laughter, as is sometimes the case. In a corner of the painting Tintoretto inscribed thus, both the name of the Grand Guardian of the *scuola* and his own:

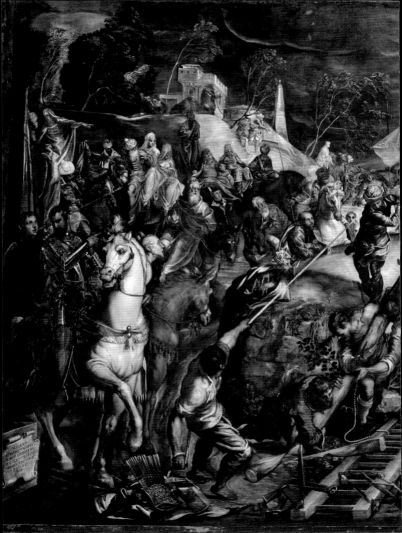

Fold-out: The Crucifixion, 1565. Above: detail of The Crucifixion

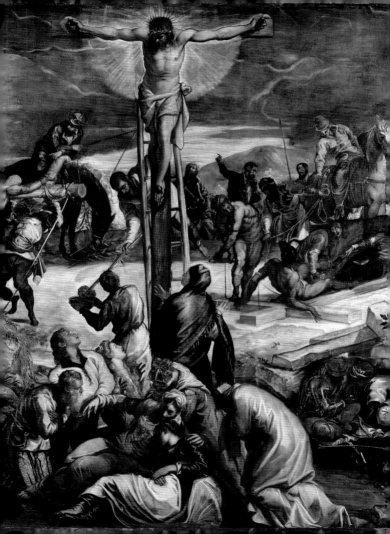

1565.
AT THE TIME OF THE GOVERNMENT OF THE MAGNIFICENT
MESSER GIROLAMO ROTA AND HIS ASSOCIATE MEMBERS
OF THE BOARD, JACOPO TINTORETTO MADE THIS.

But we will not pause to recount the praises of this immense and noble work, which would be like bringing light to the sun, since the celebrated engraver Agostino Carracci has made it known to one and all by translating it with the highest skill into a print, thus making it easy to see the beauties with which it is replete. They say that Carracci brought a copy of his engraving to Tintoretto who, when he saw how well he had been served, embraced Agostino with great emotion and praised him extravagantly. Carracci on his part was proud of having acquired whatever good he possessed from the works of so great a master. Nor were his engravings ever admired as much as when they were enriched by Tintoretto's compositions.

Passing now from the Albergo into the great chamber [Sala Maggiore], we will briefly touch on those works that Tintoretto went on to paint in accordance with the task he had undertaken. Starting with the group in the middle of the ceiling, he began work with an oval in which he represented Adam and Eve [1]

1. *Temptation of Adam*, with workshop assistance; 1577-78, in situ

who, not heeding the divine precept, ate the forbidden fruit. Next follows a picture of Moses striking the rock[1] and making gush forth in abundance the waters which a numerous crowd of stricken people collect in large basins and jars. With such a prodigious miracle did God wish to show the special protection that He gave to that people, bringing forth for them drink from the very stones. The act of bringing water out of rock should be enough to confirm the faith even the most barbarous of nations, not to speak of a favoured people. But the Hebrews, always ungrateful, turned their face against their Creator for any reason, however slight.

In the second oval we see Jonah on the beach, spewed forth by the whale so he could continue his journey to Nineveh in accordance with divine command.[2] And in the middle picture, which is about twenty *braccia** in length, he painted the Brazen Serpent which Moses shows to the people in the desert.[3] In this abundant composition we see many learned solutions that the painter used in diversifying the bodies of the various figures that, having been wounded

* 20 Venetian braccia = *c.*13 m; actual height: *c.* 8.40 m

1. 1577, in situ; ill. p. 2 2. *Jonah and the Whale*, 1577-78, in situ
3. 1575-76, in situ, ill. overleaf

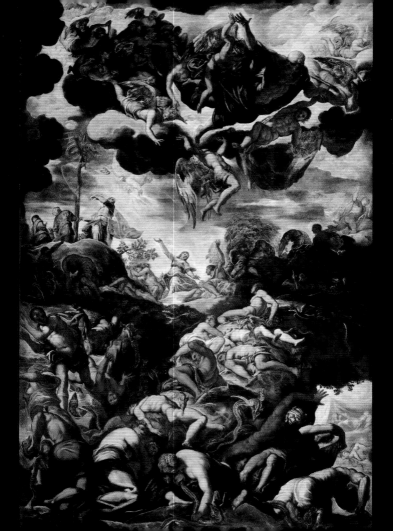

by the serpents, twist about in strange attitudes, several gripping the serpents with greater or lesser muscular power in conformity with their various physical states. One notes as well the marvellous skill he used in separating one figure from another with light and shadow so that they stand out to varying degrees, the distant figures being made to fade away with the greatest delicacy. At the top we see God the Father borne by a multitude of nude angels. Tintoretto only knew how to paint his figures in the most expert and vigorous way. But, leaving these considerations to the curious, let us go on with our discourse.

Next to it, in the third oval, is the obedience of Abraham in sacrificing his son.[1] In the third picture he painted the Fall of Manna which the lavish hand of God provided for the Hebrews in the desert.[2] Among those who gather up the manna is a standing man holding a large basin, whose pose is such that it fills those who see it with wonder. The central series is brought to a close with the Sacrifice of the Lamb, which is in the last oval.[3]

In six other spaces, these being rectangular in

1. *Sacrifice of Isaac*, 1577-78, in situ 2. *Gathering of the Manna*, 1577, in situ, ill. p. 49 3. *Passover*, with workshop assistance; 1577-78, in situ

Opposite: The Brazen Serpent, 1575-76

shape, Tintoretto painted scenes from sacred Scripture: Moses leading the Hebrews through the desert with the guidance of the pillar of fire; Jacob's ladder; and some visions of the prophets Elijah and Ezekiel.[1]

Ten large pictures were then arranged around the walls of the same hall with subjects from the New Testament. In the first is the Birth of Christ, which has a highly original composition, the Virgin being placed in the loft of a stable with St Joseph nearby and the adoring shepherds.[2] On the floor of the rustic hut others are seen bringing to the newborn God pastoral gifts, and receiving the light that radiates from the face of the Virgin and the Divine Infant. In the painting that follows, Christ is baptised in the Jordan.[3] In the distance we see a long line of people coming to be baptised. In the third, the Redeemer rises from the sepulchre.[4] The stone has been lifted by four angels whose rapid movements cause their lovely robes to flutter in graceful scroll-like shapes. The soldiers stand guard, wrapped in mantles and shadowed by the cloud that encircles the Saviour, so that we can

1. 1577-78, some with workshop assistance; in situ 2. *Adoration of the Shepherds*, 1578-81, in situ 3. *Baptism of Christ*, 1578-81, with partial workshop assistance; in situ 4. *Resurrection of Christ*, 1578-81, with partial workshop assistance; in situ

make out of them only a few highlights, strokes at
the top of the head and on the knees. These devices
were often used by Tintoretto to give greater force to
the composition and to emphasize the parts touched
by the light. In the fourth painting is represented the
Agony of Our Lord in the garden.[1] The angel who
appears to comfort Him is encircled by a great radi-
ance that sheds light on the composition. In the fifth
we behold Christ's supper with the Apostles.[2] They
are seen from a highly unusual point of view in a
ground-floor room, the scene being shown with natu-
ralness but also with a quality of awe.

On the opposite wall there follows the miracle of
the Saviour's multiplication of the five loaves and two
fishes.[3] It is an example of Divine Providence which
provides in abundance to those who direct their hopes
toward Heaven. Here we see the Saviour on the slope
of a mountain pointing to the Apostles who are dis-
tributing the bread that the youth has gathered. At
the foot of the mountain are arranged several large
figures which are painted in a bold and resolute man-
ner. The seventh painting is of the man who was born

1. 1578-81, with workshop assistance; in situ 2. *Last Supper*, 1578-81,
with workshop assistance; in situ 3. 1578-81, with workshop assis-
tance; in situ

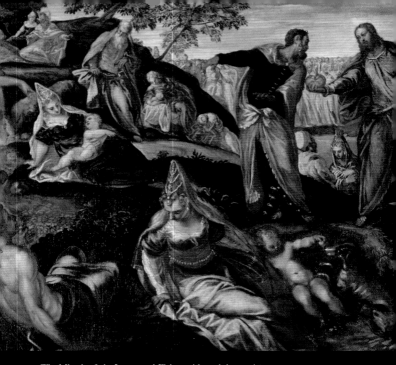

The Miracle of the Loaves and Fishes with workshop assistance, c.1545–50

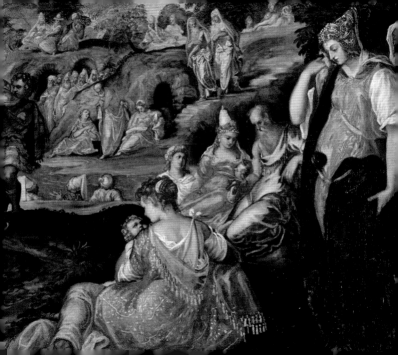

blind and is being led to Christ. The eighth is of the Ascension into Heaven.[1] In the ninth is the pool with gracious pergolas drawn in perspective, where Christ commands the paralytic to walk.[2] The last picture of that series is Our Lord being tempted by the Demon. We can no longer say the Devil is deformed, for here Tintoretto painted him in the guise of a beautiful youth with elegant tresses and bracelets on his wrists.[3] At the top of the hall between the windows are inset the figures of St Roch and St Sebastian.[4]

And finally, at the altar, he placed a canvas showing St Roch appearing to the sick.[5] In one corner he portrayed the British cardinal, his guest in Rome, who was blessed by the saint at a time when the city was tormented by the plague. The imprint of the cross remained on his forehead, protecting him from that sickness. And above the arch through which one passes to the second stairway Tintoretto placed a painting of medium size in which is depicted the Visitation of the Virgin to St Elizabeth.[6]

In the hall on the ground floor [Sala Terrena] he

1. 1578-81, with workshop assistance; in situ 2. *Pool of Bethesda*, 1578-81, in situ. Restored by Domenico Tintoretto (1602) 3. *Temptation of Christ*, 1578-81, in situ 4. 1578-81, with workshop assistance; both in situ 5. Domenico Tintoretto, *Vision of St Roch*, 1588, in situ 6. 1582, with workshop assistance; in situ

arranged in much the same way the following scenes. We see in the first space the Virgin Annunciate who speaks with the angel of the high mystery of the Incarnation while St Joseph labours at his tasks in the background.[1] He portrayed a room divided by a wall whose broken bricks are realistically depicted. In the next picture the newborn Saviour is adored by the Magi, while in the distance servants are leading camels laden with baggage.[2] In the third the Virgin flees to Egypt, holding closely in her arms our Infant Saviour who is wrapped in swaddling clothes, while St Joseph leads the donkey through a wooded area with beautiful views in the distance.[3] In the fourth he represented the Massacre of the Innocents which is perhaps the most original composition of the whole group.[4] In it several women with dishevelled hair are crying out and clasping their children tightly to their breast as they hurl themselves over a wall in an effort to escape from their executioners. Others have fallen on the ground, and among them is one who in an act of self-sacrifice grasps the sword of the executioner in an attempt, by wounding herself, to save from his cruel hands the tender young child she holds to her

1. 1582, with workshop assistance; in situ 2. 1581-82, with workshop assistance; in situ 3. 1582, with Domenico Tintoretto; in situ 4. 1583-84, with workshop assistance; in situ

breast. The last two paintings are of the Circumcision of Our Lord[1] and the Assumption of the Virgin, in which the Apostles at the tomb show by their gestures their awe on seeing their Queen ascend to Heaven.[2]

From these abundant and erudite compositions numberless artistic precepts could be garnered by showing the many skills employed in them. But since it was not our intention to write about the rules of painting, but only through a discussion of the works themselves to touch upon some of the skills and beautiful effects the artist used, we will not go beyond that point. We cannot, however, pass over in silence the honours due to Tintoretto, since we can truly say that the Scuola di San Rocco was ever the academy and home of all students of painting, and in particular of those from beyond the Alps, who from that time on have come to Venice. His works have served as exemplars leading to an understanding of how to compose with originality, how to give grace and concision to design, how to provide order by isolating, with lights and shadows, groups of figures within the composition, and how to give freedom and strength to the colours of the painting, and, in short, to do whatever

1. 1583-84, by Domenico Tintoretto; in situ 2. 1583-84, with Domenico Tintoretto; in situ

is needed to make the artist's creativity more effective. Certainly those works were not painted negligently by Tintoretto, as is believed by some who are ill-versed in the beauty of art and do not see in them a certain gradation of shading of the colours that would satisfy the eye of the less well-informed. The use of refinements and finishing is not always praiseworthy in a painter. It is undoubtedly superfluous in those compositions that are placed far from the viewer so that the intervening atmosphere unites with an extraordinary softness the bold brushstrokes, rendering them soft and pleasant when seen from a distance. Therefore Tintoretto is commended by wise artists for being able to visualize the effect that the paintings would make in their assigned location, employing a finish sufficient and proportionate to the site, and always using in a masterful way his style of bold brushstrokes which, in short, is the goal that is so difficult to achieve for those who want to make themselves thought of as great in art. It comes from long experience and from the keenness of intellect which in that extraordinary painter was unique.

We add in praise of these famous paintings that many talented Flemish engravers (not to mention Carracci) have added to his fame by translating into print those precious ideas. Among them are Ægidius

Sadeler, who engraved the Resurrection of Christ in royal folio, and Lukas Kilian, who engraved the Massacre of the Innocents and the Miracle of the Loaves and Fishes. There are also engravings of the Virgin Annunciate, the Circumcision, and other narratives of that series which those wise artists made, knowing the usefulness they would have for the scholars. And that is not to mention the countless drawings and painted copies of those works which were made by students. Tintoretto was able through the lofty level of his thoughts to stimulate all the intellects of his age, leading them through felicitous paths to become splendid and grand. And in Venice, where it seems that God blessed this art in a special way, all those who came after him were said to follow the style that he used in his compositions, in his poses, and in the great strength and energy that he expressed through his figures, and in those concepts we touched upon in our account of his works which confront the most difficult aspects of art.

That manner, followed with much diligence and praise by painters of the past and admired by connoisseurs of painting, one can still see practiced by learned Venetians; there being no need to search for novelties in the far reaches of the earth, since those painters did not lack valour sufficient to satisfy the

curiosity of the world when it could be persuaded that the valour of the painter is not due to luck, and that outward forms and ostentation often attract those who are more satisfied with opinion than with truth.

During this period Tintoretto made for Don Guglielmo, the Duke of Mantua, eight large decorative friezes for the rooms of his castle in which were depicted the principal events of that family. He represented the Battle of Taro, led by Marchese Francesco Gonzaga,[1] and other victories won for the Venetian Republic. He also portrayed the ceremony by which the Emperor Charles V conferred the title of Duke,[2] as well as other events in the history of the Gonzaga family. While working on the friezes, Tintoretto was often visited by the Duke, who was in Venice at that time. Don Guglielmo took the greatest pleasure in watching Tintoretto paint. The Duke enjoyed his gentle manners, for the artist was able with much grace to adapt himself to anyone, and was especially adept at the delicate art of dealing with the great.

When the friezes were completed he was invited by

1. Jacopo and Domenico Tintoretto, *Francesco II Gonzaga Fighting at the Battle of the River Taro*, 1578-79, Munich, Alte Pinakothek
2. Domenico Tintoretto and workshop, *Gianfrancesco Gonzaga created Marquess of Mantua by Emperor Sigismund*, 1578-79, Munich, Alte Pinakothek

the Mantuan Ambassador, in the name of the Duke, to come to Mantua with the paintings in order to assist in placing them in the spaces where they were to go. Tintoretto, who in fact welcomed the opportunity to go to Mantua with his wife to visit the family of her brother who lived there and was much loved by the Duke, said he could not go, and begged the ambassador to present his excuses to his highness. On being asked why he refused, he replied that his wife wanted to go with him no matter where he went. When he heard that the ambassador said that he would not fail in his service to his lord, the Duke, and that Tintoretto could take not only his wife but his whole family. Having ordered that one of the small ducal barges be well-furnished with provisions and made ready for him, Tintoretto set off for Mantua with his wife. There he stayed for many days at the court, where he was welcomed by the Duke with much kindness and munificent expenditure. The Prince often spent time with the painter, discussing with him some of his ideas for buildings and new projects for the city. And he put Tintoretto's counsel into effect, as one can only receive useful precepts from wise painters, because that art embraces all knowledge pertaining to design. The Duke also wanted Tintoretto to remain at his court, but because of the many public and private

works that the artist had left unfinished in Venice, he was unable to stay. Another reason was because it was always irritating to him, as an honourable man, to feel himself bound by chains even though they were embellished with gold and jewels.

To remind posterity of the victory that the Republic won against the Turks in the year 1571, the Senate decided to have a representation of that glorious event in the Voting Chamber [Sala dello Scrutinio]. They gave the commission to Titian and also assigned Giuseppe Salviati as his partner in order to lighten the load. But for whatever reason (and here the reports disagree), the beginning of the work was continually put off, thus giving Tintoretto, who wanted to execute every painting for the city by himself, a chance to get the commission. He therefore went to the Collegio, and told the Doge and Senate that as a good citizen of Venice he had always harboured an immense desire to prove the affection of his heart to his prince by deeds. This then he would demonstrate by creating with the lights and darks of his paints that glorious victory which was won by the force of Venetian arms to the great applause of the world. He said also that with his mute brushes, in the guise of tongues, he would add to the general joy, and he promised to render every good service without recompense, deeming the

praise of having well served his Prince to be enough payment. He added also that he promised within the space of a year (notwithstanding the many projects he had on hand) to turn over the completed work. He further pledged that if any painter in the space of two years could bring to completion a similar undertaking, he would yield the field and would promptly take down his painting if a better one were put up. Such resolutions do not enter into base hearts, but only into generous spirits that aspire to great honour.

The Senate, therefore, being well aware of Tintoretto's already proven worth and seeing that little advantage could be drawn from Titian, who was burdened with age, decided to give him the commission. He portrayed that great and glorious victory in such a way that we can see in it the main events.[1] Among these are the capture of the galley of the Turkish general Ali Pasha, and the lifelike portraits of Sebastiano Venier, the Venetian general, and Don John of Austria, as well as Marcantonio Colonna, who sailed for the pope and rallied the warriors who were exposed to the battle's greatest danger.

He likewise showed the wounding of Agostino Barbarigo, the Venetian *provveditore*, who was struck in the

1. *Battle of Lepanto*, 1571–74, lost in a fire (1577)

eye by an arrow that cost him his life (those crimson drops adorn his name with eternal glory). He also showed many clashes of galleys filled with soldiers, and, hurling clouds of arrows, a horde of Turks, many of whom through the action of the battle fall into the sea and drown. He also painted other galleys in the distance which were skilfully illuminated by the fire of mortars and arrows streaking through the air. These far-off galleys the artist painted in this manner in order to thus separate them from nearby vessels, ingeniously veiling them in mists and dark clouds. In the same way he laid out on the plains a great multitude of soldiers with spears, swords, bows, crossbows, and other instruments of war which make a cruel slaughter of the enemy. In short he arranged everything in that grand medley without confusion and in accord with the accurate precepts of art. Titian scorned this excellent work, as did his followers, who had a great hatred of Tintoretto because he interjected himself into all their affairs. In truth they had no greater obstacle to fame than him. His brush was, so to say, a thunderbolt that terrified everyone with its lightning. But the Senate, in order to respond with gratitude to such a great service, decided to reward him with an annuity to be passed on, with other benefices, to his descendants.

For the visit of Henry III, the King of France and

Poland, Tintoretto painted together with Paolo Ve-
ronese some figures in chiaroscuro in the arch built
on the Lido, after the design of the architect Andrea
Palladio.[1] But since Tintoretto had arranged to paint
the portrait of the king whose arrival was imminent,
he sought to get away, requesting Paolo to finish with
his own inventions the little bit that remained to be
completed in the arch; and taking off his toga, he
clothed himself like one of the Doge's equerries, and
mingled with them in the Bucintoro, the ducal barge,
which sailed out to welcome the king. During the voy-
age he secretly painted the proposed portrait of him
in crayon. This small sketch he used as the basis for
the life-size portrait. Having become a friend of the
treasurer of the King, Monsieur le Duc de Bellegarde,
he was, after many delays due to the continual visits
of princes, shown into the royal quarters in order
to do the retouching from life. While he was in the
process of painting and the King was graciously ad-
miring his work, a shipwright from the Arsenal dar-
ingly entered the room and presented his badly made
portrait, saying that when His Majesty had dined at
the Arsenal he had drawn that likeness. His temer-
ity was squelched by a knight who pulled it from his

1. 1574, destroyed

hands and, piercing it with his dagger, threw it into the Grand Canal nearby. This affair gave rise to the rumour that went around that Tintoretto's portrait was considered unsatisfactory.

Tintoretto also noted on that occasion that from time to time there were presented to the King certain persons whom he lightly touched on the shoulders with his sword, to the accompaniment of other ceremonies. Pretending not to understand the significance of this, he asked Bellegarde about it. The latter told him that in this way they were created knights by His Majesty and that he too should prepare to receive that rank, since he had talked about it with the King, and the King appeared to be ready (knowing his condition) to recognise Tintoretto's merit by making him too a knight. But the artist, perhaps not wishing to subjugate himself to titles, modestly refused the honour.

He then presented the portrait to the King, who happily received it, considering it to be a marvel since, although the artist had made it almost by stealth, he portrayed him true to life and with royal dignity.[1] The King made a gift of it to His Most Serene Highness Alvise Mocenigo, at that time the doge of Venice, in whose house it is still.

1. 1574, lost

But since up till now we have spoken of many of his principal works, discussing them to the best of our ability in chronological order, we will now deal with a large group of paintings and altarpieces scattered throughout the churches of Venice that he painted during his most vigorous period.

For the sanctuary of San Cassiano he painted two large canvases. In one we see the Saviour crucified between the two thieves, with many soldiers on the mountain plain, and an executioner who had climbed a ladder so as to place the inscription on the cross.[1] The other is of the liberation of the Holy Fathers from Limbo;[2] and in an altarpiece is the Resurrection of Our Glorious Lord, with St Cassian Bishop and St Cecilia beside the sepulchre.[3]

In the church of Santa Maria Zobenigo [Santa Maria del Giglio] he painted the Four Evangelists on clouds writing the Scriptures on the inner face of the organ shutters,[4] and on the outer side the Conversion of St Paul.[5] For an altar for the Duodo family he painted the Saviour and St Justina with a lifelike portrait in the figure of St Augustine.[6]

1. *Crucifixion*, 1568, in situ; 2. 1568, in situ 3. 1565, in situ 4. *The Evangelists Mark, John, Luke and Matthew*, 1557, in situ, ill. opposite. 5. Lost 6. Domenico Tintoretto and workshop, *Christ with Angels and Sts Justina and Francis of Paola*; 1581-82, in situ

The Evangelists Mark, John, Luke and Matthew, 1557

For the main chapel of the church of Santa Maria Assunta of the Crociferi Fathers he painted the Assumption of Our Lady;[1] and although the Fathers had decided that Paolo Veronese should paint that picture Tintoretto was able to talk them into giving him the commission, promising them that he would paint it in the manner of Veronese, so that it would be thought to be by his hand. Nor was his promise false, since, in fact, he created in that altarpiece a blend of vigour and charm which decisively proved that he knew how to paint in any style, and could change to whatever manner was pleasing. The heads of the Apostles he painted in a most vivacious manner, with the lights in their eyes shining as if the Spirit possessed them, and he placed them in such lively and animated poses that it is useless to ask for figures that are more beautiful or movements more gracious.

In the same chapel he also painted, in competition with Schiavone, a medium-sized picture of the Circumcision of Our Lord, placing the table (on which the Priest and the Virgin with the Infant in her arms lean) in such a manner that below it distant figures and a glimpse of architecture are seen, thus making of it something strong and wonderful, which in fact

1. *c.* 1555-60, in situ (today church of Gesuiti)

148

greatly surpassed the painting of his rival.[1] It is with good reason that this is held to be among Tintoretto's most prized works.

On a great vault in the refectory belonging to the same Fathers (who, as a result of the works he had done in their chapel, were amazed by his talent) he painted the Wedding at Cana.[2] Christ is at the end of the table, with the Virgin at his side and a long train of guests, and there are many servants scattered throughout the room who bring food and bread in vessels and pour water changed into wine. By the position of the table and the partitioning of the ceiling, which is divided into many spaces all drawn in perspective, the refectory is so elongated that the tables and guests seem to be doubled. The composition is reproduced in an engraving by Odoardo Fialetti of Bologna, a student of Tintoretto's work.

There are two of his altarpieces in the church of San Felice. The larger shows St Roch with saints on either side and is uncommonly beautiful in its colouring.[3] The other contains a small figure of St Demetrius in armour and a portrait of the patron, who was

1. *Presentation of Christ in the Temple*, c. 1550-55, Venice, Accademia, ill. overleaf. 2. 1561; Venice, Santa Maria della Salute 3. Possibly Gian Pietro Silvio, *St James with Sts Paul, Nicholas, Andrew and Bernardino*, c. 1540, in situ

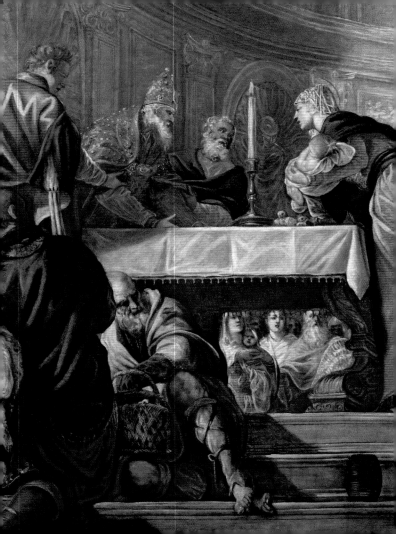

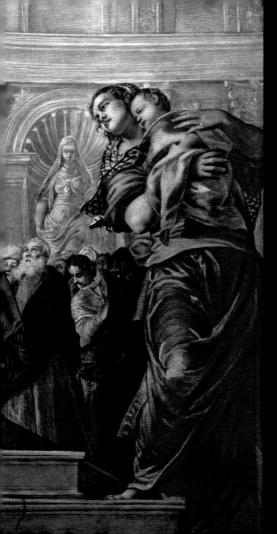

*Presentation of Christ
in the Temple,
c. 1554–56*

a member of the Ghisi family.[1] In the Chapel of the Sacrament are paintings of the Last Supper[2] and the Agony in the Garden.[3] In another chapel in a half-lunette there was a picture of Our Lady Annunciate.[4]

In the church of San Moisè in the Chapel of the Sacrament he painted a picture of Our Lord washing the feet of His disciples.[5] In the background servants are seen removing the tablecloths from the tables and in the corner there are portraits of the Rector and the Guardian of the Confraternity. There is also a small altarpiece of the Virgin called Our Lady of Graces.[6]

For the Compagnia of Nostro Signore in the church of Santi Gervasio e Protasio [San Trovaso] he painted another Holy Thursday Supper of new and curious invention.[7] In it Christ is seen blessing the bread, while the Apostles are seated on humble chairs around him, devoutly gesturing while some bring food to the table. In it, too, are a boy bringing a plate of fruit and an old woman spinning at the top of a stairway, both painted with great naturalism. An engraving reproduced the composition.

1. Possibly Giovanni Galizzi, *St Demetrius with Portrait of Gian Pietro Ghisi*, *c.*1550, in situ 2. 1559, with workshop assistance; Paris, Saint François Xavier 3. Unidentified 4. Unidentified 5. *c.*1585-90, with Domenico Tintoretto; in situ 6. Untraced 7. *Last Supper*, *c.*1563-64; in situ

And thanks to Antonio Milledonne, Secretary of the Senate, he painted for the altars of his chapel a St Anthony Abbot being tempted by demons in the guise of delicate, elegant women.[1] The Redeemer appears to him in an aureole and the saint with his eyes fixed on Him seems to be consoled. And in this work, truly most rare, he demonstrated how well he knew how to bring his paintings to an exquisite finish when he judged it opportune and when the occasion and the quality of the place required it. It too is engraved.

At the foot of the crucifix of the church of Santi Giovanni e Paolo we see in a small painting three scenes from the Bible, all of which allude to the death of Christ: Cain killing Abel, Abraham sacrificing Isaac, and the Brazen Serpent which Moses erected in the desert.[2]

In the chapter house of the same fathers there once was an altarpiece of St George killing the dragon, but the original is now missing and only a copy is left.[3] Some small figures by Tintoretto remain in the pediment above the altar.

There was also in the church of San Francesco della Vigna in the Bassi Chapel an altarpiece of the

1. *c.*1577, in situ 2. All untraced 3. Replaced by copy in the 16th century

Lamentation over the Body of Christ[1] with Nicodemus and Joseph compassionately supporting the precious body and servants with torches that illuminate the shadows of night, at which sorrowful spectacle the Virgin swoons. It was one of Tintoretto's most precious paintings but was mutilated by a sacrilegious hand. All that is left us is an angel with the crown of thorns in its hands at the top. In the sacristy of San Sebastiano there is a little painting containing a story from the life of Moses.[2]

In the church of Santa Maria Mater Domini he portrayed St Helena finding the True Cross.[3] The Queen he painted in a majestic attitude with her retinue of ladies so dressed as to seem drawn from antiquity, and arranged in graceful and noble attitudes. From it we come to understand Tintoretto's studies, and the large collection he made of things that were curious and beautiful. Here too we see how, by contact with that which has touched Christ, the sick woman at the side of the cross is cured. St Macarius, Bishop of Jerusalem, is present, together with many people who show their amazement on seeing so great a miracle. In short, the work is replete with skilled draughtsmanship, strength, grace, and painterly artifice.

1. c. 1563-64; Edinburgh, National Galleries of Scotland 2. Unidentified 3. 1561, in situ

Above the door of the church of the Carità there once was seen a painting of the Saviour on the Cross, a work so noble and delicate that it breathed divinity.[1] At the foot of the cross there was the usual group of the weeping Maries and on the sides some bishops. But of that painting one may now say with the angel: 'He is not here: for He is risen.'

In the church of San Polo one admires another Last Supper where Our Lord gives communion to the Apostles, which differs from all other interpretations of that theme, for Tintoretto was not lacking in new concepts, his genius being a treasury of all the most beautiful curiosities.[2]

Besides the paintings we have already noted, there are some fourteen altarpieces, scattered throughout other churches, that we will briefly mention. In [San Salvatore degli] Incurabili there is one of St Ursula who, followed by many virgins, has disembarked from the nearby boat and is carried off from the midst of prelates, while an angel brings her the martyr's palm.[3] The second is in San Daniele, wherein St Catherine resolves the doubts put to her by philosophers with such grace and alacrity that only speech is lacking to make us believe her alive.[3] The third, in the Gesuati

1. Destroyed 2. 1568-69, in situ 3. c.1575-80, with workshop assistance; Venice, San Lazzaro dei Mendicanti 4. Destroyed

[Santa Maria del Rosario], is of the Crucifixion[1] with the Virgin Mother at the foot as Nicodemus and Joseph carry out the compassionate office of taking down the Saviour from the cross. The fourth altarpiece, in San Giuseppe di Castello, is of St Michael, and it also contains the portrait of a Venetian senator.[2] The fifth is in San Girolamo [dei Gesuati], with Christ on the Cross sustained by God the Father in Heaven; St Adrian is at the foot of the cross, and St Francis and St Anthony are on their knees.[3] There are two paintings by Tintoretto in Santi Cosma e Damiano on the Giudecca, one of which shows Saints Cosmas and Damian dressed in a ducal manner, with the Virgin and other saints on clouds.[4] The smaller one is of Christ[5] and there is also a painting of the Agony in the Garden.[6] The ninth, which is in San Marziale, is of that saint in a radiance with the Apostles Peter and Paul on either side.[7] The tenth,

1. *c.*1565, in situ 2. *Archangel Michael in Combat with Lucifer in the Presence of Michele Bon*, *c.*1581, in situ 3. Possibly workshop, *Trinity*, *c.*1580-90, Turin, Galleria Sabauda 4. *Virgin and Child with Sts Cosmas, Damian, Secondus, Marina and Cecilia*, with workshop assistance, *c.*1579, Venice, Accademia 5. Possibly workshop, *Crucifixion, c.*1575-85; Selva del Montello parish church (on loan from Venice, Accademia) 6. Unidentified 7. 1549, in situ

Opposite: St Martial with the Apostles Peter and Paul, 1549

in Santa Croce, shows the Dead Christ supported by an angel and includes a portrait of the pontiff Sixtus V.[1] The eleventh, in San Geminiano, shows St Catherine in prayer and an angel who points out the wheel which is held by two cherubs.[2] The twelfth, in the little church of San Gallo in Campo Fusolo, is of the Redeemer with St Mark and the eponymous episcopal saint.[3] In Santo Stefano Confessore, called San Stin, is the thirteenth, in which is depicted the Assumption of the Virgin.[4] And, finally, the last is in the Compagnia della Giustizia in the Scuola di San Fantin; in it we see St Jerome praying in a grotto covered by rough planks as he beholds a vision of the Virgin upheld by four lovely angels.[5] Among those altarpieces I have noted, this one is, I believe, worthy of much praise for the special study and diligence Tintoretto used: in this instance he took into account its placement only a little above the floor. Moreover he portrayed the saint in a manner appropriate to his years, noting the wrinkles and creases that occur in the skin of an old person, without at the same time compromising the design.

1. Destroyed 2. *Vision of St Catherine*, with workshop assistance; *c.*1565-75, private collection 3. *c.*1540-45; Venice, Museo Diocesano 4. *c.*1550; Venice, Accademia 5. *c.*1580; Venice, Ateneo Veneto

And although it is sometimes observed that he cared more about developing his ideas than creating pleasing effects with finishing touches, he nevertheless often demonstrated that he knew how to bring his works to the point where everyone could see there was no part of the painting that was not executed perfectly, and that sometimes he could even be called a painstaking miniaturist.

Let us speak now of his fresco works since that way of painting is no less worthy than working in oil. The resolute manner which is appropriate to fresco does not permit cancelling and redoing things at the painter's pleasure, for then it would be flawed, and the changes would show, much to the disgrace of the artist.

In the house of the Gussoni family on the Grand Canal Tintoretto painted copies, during his youth, of two figures taken from Michelangelo: *Dawn* and *Dusk;* and in two areas on the upper section he painted two original compositions: Adam and Eve, and Cain killing Abel.[1] Similarly in Campo Santo Stefano on the back of a chimney he painted the figure of St Vitalis on horseback, sharply foreshortened, which

1. 1550-52, destroyed, but known through engraving by Anton Maria Zanetti (1760)

was praised by master painters as something extraordinary. Here as a caprice Tintoretto based his design on the statue of Bartolomeo Colleoni in the Campo dei Santi Giovanni e Paolo, the celebrated sculpture that was the last work of the Florentine, Andrea Verrocchio. On the vaults by the windows he painted some nudes which were executed with skill and in so pleasing a manner that had they been painted in oil they could not be fresher or better. In such ways he demonstrated how talented he was in comparison to others.[1]

But among the works in fresco the most acclaim was for the one for the façade of the house of the Marcello family in the parish of Santi Gervasio e Protasio, called San Trovaso. There he painted four fables from Ovid: Jove and Semele; Apollo flaying Marsyas; Aurora taking leave of Tithonus; and Cybele crowned with towers in a chariot drawn by lions. Above these pictures he executed a long frieze filled with nude bodies of men and women so vigorously and freshly painted that they seem alive.[2] It is moreover the most curious interweaving of figures that a painter could devise. Thus the artist perfected his skill

1. All destroyed 2. All destroyed, but known through engraving by Silvestro Maniago and Andrea Zucchi (1720)

at handling the various techniques through which one learns the working of his genius and that universality that painting requires.

But let us pass on to the Ducal Palaces and speak first of the paintings in the upper rooms where Tintoretto had ample scope to demonstrate his ideas.

In the Salotto Dorato at the top of the stairs leading to the Collegio, he painted on four medium-sized canvases various subjects appropriate for the government of the Venetian Republic.

The first is of Vulcan with the Cyclops, who take turns striking the iron on the anvil and attempt to bring it to a perfect shape.[1] This suggests the unity of the Venetian Senators in the administration of the Republic. The various pieces of armour seen on the ground allude to the instruments which in military matters make for power, since arms serve both to ornament cities and to terrify their enemies.

In the second are the Three Graces accompanied by Mercury.[2] One is leaning on a die, for each of the Graces has an attribute. The other two hold the myrtle and the rose, both sacred to the amorous goddess, symbols of perpetual love. They are accompanied by Mercury to show that the Graces bestow themselves

1. 1578, in situ 2. 1578, in situ

with good reason, just as favours are bestowed by the Senate on its deserving citizens. The Prince who recognises virtue and services rendered resembles God, who leaves no good unrewarded.

The third painting shows Mars driven away by Minerva while Peace and Prosperity celebrate.[1] By Minerva here is meant the Republic's wisdom in keeping war far away from the state, thus bringing happiness to its subjects and giving rise to love for its prince.

In the fourth we see Ariadne, whom Bacchus found on the shore.[2] Venus gives her a crown of gold, declares her free, and admits her to the company of the gods. By this is meant that Venice, born on the sea's shore, was through heavenly grace given an abundance not only of every earthly good but adorned as well by the divine hand with freedom's crown, and that her dominion is recorded in everlasting letters in Heaven. So noble in concept and so graceful of body are these figures that surely they breathe a divine inspiration that steals our hearts. And if ever it be true that Nature was conquered by Art, here without doubt she surrendered the palm to her rival Painting. Two of those compositions are to be seen in engravings by Carracci, to whom we referred earlier.

1. 1578, in situ, ill. p. 30 2. 1578, in situ, ill. opposite

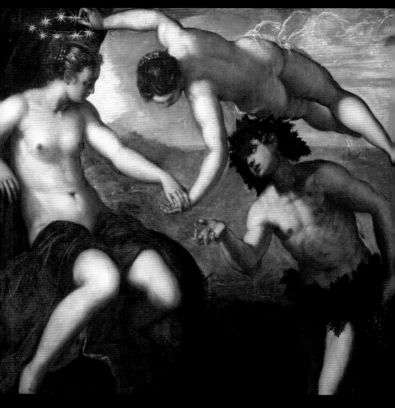

Bacchus, Ariadne, and Venus, 1578

In the middle of the ceiling Tintoretto placed the portrait of the Doge Girolamo Priuli,[1] to whom Justice, accompanied by Venice, hands over the sword and scales, bestowing upon him dominion over his people, while above in the sky reading a book in a graceful pose is St Mark, the Protector of Venice. He then went on to paint the vault of the nearby room called the Sala degli Stucchi. In the central panel he painted Venice led by Jupiter to the bosom of the Adriatic, while all the gods with happy countenances assist at the foundation of the city.[2] There is likewise in one of the tondi a figure of Venice holding in her hand a broken yoke and shattered chains.[3] She is accompanied by many allegorical figures of virtues, one of whom holds a cap on a lance as a sign of liberty. At her feet stands Envy with serpents about to be overthrown. These paintings, being damaged, were restored by a painter of little skill. In the other tondo Juno bestows on Venice riches and power, giving her the peacock and thunderbolt along with other gifts borne by her assistants.[4] Venice and Juno are surrounded by the four principal cities

1. *Doge Girolamo Priuli, Accompanied by St Jerome, Before Peace and Justice*, with workshop assistance; 1562-65, in situ. Partially incorrect identification by Ridolfi 2. 1577, in situ. Partially repainted in the 18th century 3. Workshop; 1577, in situ 4. Workshop; 1577, in situ

of the state. Two of these, Altino and Vicenza, which were ruined by time, have been restored by Signor Francesco Ruschi, a diligent and worthy painter.[1]

In a lunette over the windows on the canal side was the Marriage of Venice and Neptune, making her the ruler of the sea. On the opposite side by the courtyard he painted Venice favoured by the world as being unique in always keeping her empire free.[2] Tintoretto then went on to paint several works in the Sala del Pregadi. In a long space over the tribune, in conformity with established custom he portrayed the two doges Pietro Lando and Marcantonio Trevisan in adoration before the dead Saviour,[3] who is borne by angels, with the patron saints of Venice arranged on either side. In another painting in the same room he executed the portrait of the Doge Pietro Loredan before the Queen of Heaven with St Mark and other saints, and in the background we see the Piazza of San Marco drawn in fine perspective.[4]

In the middle of the ceiling surrounded by many gods in the sky he portrayed Venice. On the order

1. Workshop; 1577, in situ. Largely repainted in the 17th century
2. Domenico Tintoretto and workshop, c.1588-92; both in situ
3. c.1582, with workshop assistance; in situ 4. c.1582, with workshop assistance; in situ

of Mercury, Tritons and Nereids bring to her, as to a reigning Queen, tributes from the sea: shells, coral, pearls, and other precious things.[1]

To complete the decorative programme there remained only the paintings of the Collegio. The work was divided between Paolo Veronese and Tintoretto. The latter was assigned four large works with the portraits of the doges. Having Veronese as a competitor caused Tintoretto to put greater effort into these paintings, for rivalry sometimes serves as a spur, making the artist more attentive so as not to fall behind his competitor.

The first painting, which is near the tribune, is of the Doge Alvise Mocenigo, who is shown on his knees adoring the Redeemer. St Mark is at his side. In the background are his patron saints, as well as two portraits of senators of the Mocenigo family.[2]

In the second he painted Nicolò da Ponte with Our Lady, accompanied by St Joseph, beneath a large baldachin supported by cherubs. St Nicholas, St Mark, and St Anthony are by the Doge.[3] Tintoretto inscribed his name on that picture, considering it to be something special.

1. 1581-84, with workshop assistance; in situ 2. *c.*1582, with workshop assistance; in situ 3. 1581-82, with workshop assistance; in situ

The third painting shows Francesco Donà with St Mark along with St Francis; and he also depicted the marriage of St Catherine Martyr to the Infant Jesus. At a little distance is Prudence holding a scroll on which is written 'In order that Prudence might never be lacking in great deliberations'. Temperance also holds a scroll on which we read 'Thus Temperance has always given citizens examples to follow'.[2] These were virtues admired in that worthy prince. Finally, over the principal door we see Andrea Gritti with the Virgin on a pedestal. There are many saints about her, among them St Marina with the palm in her hand to commemorate the conquest of Padua, which occurred on her feast day; Gritti was at that time the *provveditore* of the Venetian army.[3]

It being necessary to redo the paintings of the Hall of the Great Council and of the Voting Chamber [Sala dello Scrutinio] because of the fire that had taken place in these rooms, Tintoretto was chosen as one of the principal painters. To him were assigned the four corners of the ceiling, on which he painted glorious events of the Venetian Republic.

In the corner toward the Quarantia he painted

2. 1581-82, with workshop assistance; in situ 3. 1581-82, with workshop assistance; in situ

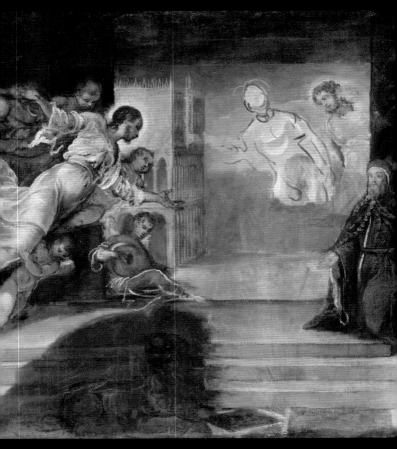

Doge Alvise Mocenigo Presented to the Redeemer, 1571-74

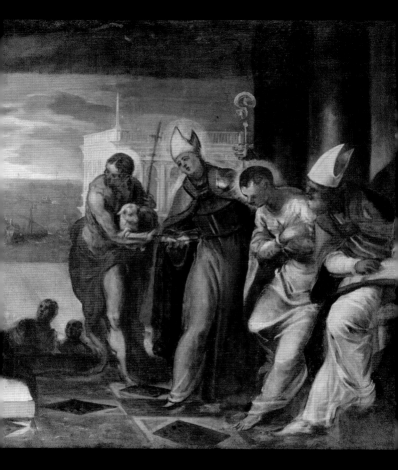

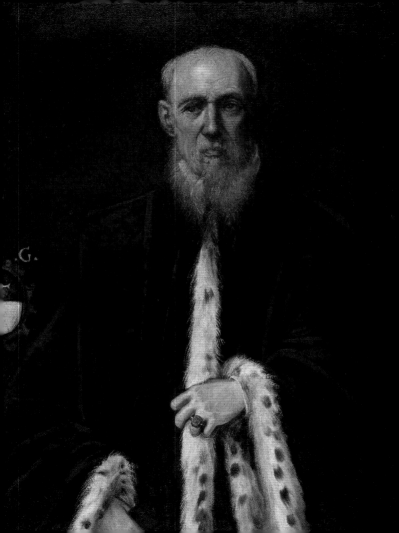

the Defence of Brescia.[1] The city was held through the prudence of Francesco Barbaro, who during the siege bore with the greatest endurance the deprivation of food, in order to serve the citizenry. We see him portrayed on a rampart with Brigida Avogadro, a generous Brescian lady, while the city was under siege by the troops of Filippo Maria Visconti, the Duke of Milan. This picture is commonly called 'the sword' as there is a soldier outside the walls who brandishes a large sword against the enemy. This figure astonishes the viewer by the dramatic way it is foreshortened to adjust to the angle from which it is seen, and also by the soldier's upright posture and bold movement. In a gold inscription nearby we read:

BRESCIA WAS SAVED FROM A MOST CALAMITOUS SIEGE
FIRST BY THE ADVICE AND BY THE MANIFOLD
SKILL OF THE COMMANDER.

In the second corner there is a painting of the victory won by Stefano Contarini over Assereto, Captain of the aforementioned Duke. Here the marvellous outdoes itself, for Tintoretto has with such great art

1. Workshop (poss. Antonio Aliense); *c.*1579, in situ

Opposite: Portrait of the Procurator Alessandro Gritti, with Domenico Tintoretto, c. 1580

171

known how to represent the lake and the galleys all properly foreshortened, and has done so with such great skill that we are amazed at the sight of it.[1] Many soldiers cross over to the enemy boats on gangways. On the inscription we read:

WITH THE FLEET OF MILAN SCATTERED IN LAKE GARDA, THE LEADERS FLED, THUS THERE IS REJOICING IN HAVING SEIZED MORE GRAND VICTORIES AND IN HAVING CAPTURED GREAT PRINCES.

The third one, facing San Giorgio Maggiore, depicts the defeat inflicted on Sigismondo d'Este by Vittore Soranzo, who captured Comacchio and took as prisoners many enemy captains and cavaliers.[2] It has the following inscription:

THE D'ESTE PRINCE IS VANQUISHED IN BATTLE AT ARGENTA TOGETHER WITH A GROUP OF NOBLES AND A GREAT MULTITUDE OF CAPTIVES.

The fourth shows Giacomo Marcello taking Gallipoli from the Aragonese.[3] In these scenes Tintoretto showed many sailors fighting on the spars of the ships

1. Workshop (poss. Antonio Aliense), *Battle at Riva del Garda*; c. 1579, in situ, ill. opposite 2. Workshop (poss. Antonio Aliense), *Battle of Argenta*; c. 1579, in situ 3. Workshop (poss. Antonio Aliense); c. 1579, in situ

Battle at Riva del Garda, c. 1579

and a group of the most fierce-looking soldiers that could be imagined. The inscription briefly explains the story:

GALLIPOLI WAS CAPTURED WHILE ARAGON FOUGHT
THE COMBINED ARMIES OF ITALY.

On one of the largest wall areas on the court side he painted in a great picture the embassy that the Venetian Senate sent to the Emperor Frederick in Pavia because of the differences between him and Pope Alexander III.[1] He painted the Emperor seated on a throne under a gold canopy at the top of a flight of stairs, the landing of which is occupied by dukes dressed in gold mantles, ermine collars, and ducal caps. The aforesaid ambassadors set forth their proposal to him. In the background are the resident ambassadors, the Papal Nuncio, and the Venetian, behind whom we see the German Guard and many people assembled in the form of an arc. At the front he painted a gathering of cavaliers and courtiers, so as to make the scene fuller and more decorative. It is a composition that has always highly pleased the connoisseurs.

In addition, in the Sala del Maggior Consiglio,

1. 1553; lost in a fire (1577)

Tintoretto was assigned the painting of an area about forty feet long in the middle of the ceiling. There he shows a life-size portrait of the Doge Nicolò da Ponte at the top of a stairway accompanied by Senators admiring the personification of Venice, who is seated above in the sky.[1] Accompanied by Cybele and Thetis who symbolise her dominion over land and sea, and by other airborne allegories, Venice, as a sign of peace, brings to the doge a wreath of olives held in the mouth of her lion. In the front there are several ambassadors of cities that had voluntarily put themselves under the protection of Venice, and they bring on large platters their keys and charters. He also arranged on the steps secretaries of the Senate officials, ministers, and subjects who mount the stairs with petition in hand, as well as foot soldiers finely dressed, bearing arms and furled flags.

But although the painting was the work of a great master, and once in place it was pleasing to the sight, yet Tintoretto could not escape the stings of his opponents (since virtue is always accompanied by envy). They spread the story that he had dashed it off as a practice work executed in a careless manner, and he

1. Workshop (possibly Domenico Tintoretto and Antonio Aliense), *Triumph of Doge Nicolò da Ponte*, c.1579, in situ

therefore feared he would encounter some criticism. But Leonardo Corona, Antonio Aliense (Antonios Vasilakis), and Giovanni Francesco Crivelli, young painters of much merit who were his supporters, had hidden among the benches in order to hear what they were saying about the picture and now and then came forth in his defense. In this way the persecution was overcome, and the painting, to the glory of its author, is held in good repute by all and with the passing of the years it has come to be revered as a precious work.

One of Tintoretto's greatest accomplishments in those rooms (apart from a number of doges' portraits [1] he painted for the frieze of the cornice of the Hall of the Great Council) was his picture of the Recovery of Zara [2] in the Voting Chamber, which one can say without exaggeration is a sun amid lesser stars. Zara had rebelled against the dominion of Venice and called in the army of King Lajos of Hungary. Subsequently the Senate sent, under the command of Marco Giustinian, a powerful army that laid siege to the town. Tintoretto portrayed the action thus: in the distance we see the Venetians attacking the city walls, which the inhabitants of Zara try to defend.

1. Lost in a fire (1577). Repainted by Domenico and workshop, in situ 2. 1582-87, with workshop assistance; in situ, ill. pp. 178-79

Nearby is a large machine that hurls back the as-
sailants on their perilously tottering ladders. The con-
flict between the King's men who have come ashore
and the Venetian army takes place on the broad
field. We see groups of foot soldiers in closed ranks
facing the cavalrymen. Bands of archers are hurling
clouds of arrows, while others are in confused flight
on horseback. Many groups of soldiers fight fiercely.
Meanwhile fresh Venetian soldiers are coming from
the galleys and are met by the Hungarians. In the fore-
ground there is a mass of disorganized soldiers armed
with spears, pikes, halberds, bows, and crossbows who
are making a horrible massacre of the enemy. Among
them is an archer gracefully drawing his bow. There
is also a confused jumble of broken wheels, scattered
insignia, and severed armour; and among these ru-
ins we see many soldiers cruelly slaughtered by the
enemy.

In short, Tintoretto displayed an instance of field
warfare, full of the most cruel happenings such as usu-
ally occur in like circumstances. And in truth that scene,
filled as it is with so much action, could only be rend-
ered with such force and expression by the unequalled
brush of such an artist. In this work he surpassed

Overleaf: Recovery of Zara, with workshop assistance, c. 1582-87

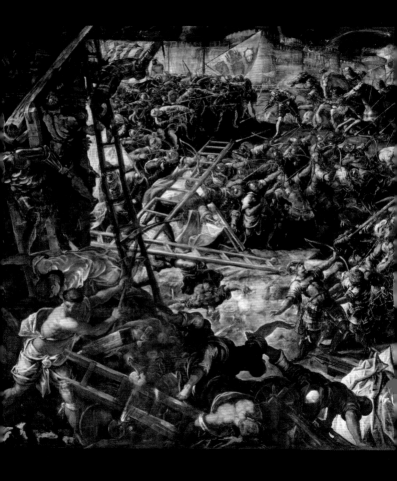

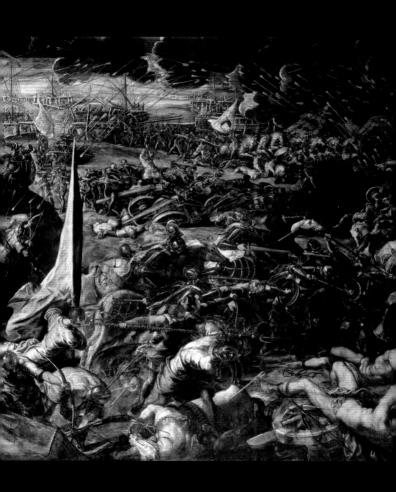

everyone's expectations; being, in sum, his own rival, his glory is finally assessed by the very works that he painted in those rooms, which gloriously carry off the palm.

So that we may not fail to relate what diligence demands, let us speak of the pictures that he painted elsewhere, although the bulk of the work he did is to be seen in Venice, where he had abundant opportunity to make himself known as a great painter. It is for those who are true connoisseurs to gauge the value of so great a man and to do so especially from those works which are characteristic of his genius, and by which his merit can be understood. His genius must not be confined to a small canvas and one cannot include everything he painted, as sometimes he dashed off little things for the pleasure of his friends. One cannot expect the painter to perform marvels in every small thing, since he often has to adapt himself to the occasion and the time available.

There are two of his pictures in the cathedral in Lucca. One is a Last Supper with Christ and the Apostles,[1] the other the Ascension into Heaven.[2] Both of them are highly admired.

In his maturity he painted a Vision of St Augustine appearing to some of his devotees for the Godi altar

1. Domenico Tintoretto, 1594, in situ 2. Destroyed

in San Michele in Vicenza.[1] In it are included some skilfully foreshortened nudes. In a villa for the same family he painted several things in fresco.

In Genoa in San Francesco we see a canvas of Christ baptised by St John,[2] and in the houses of the noblemen of that city and of other private individuals there are a number of portraits and other pictures.

In the church of San Matteo in Bologna there are two paintings of the Virgin Annunciate,[3] and in San Pietro Martire there is the Visitation of the Virgin to St Elizabeth.[4]

In the church of Sant'Afra in Brescia he painted the Transfiguration of Our Lord on Mount Tabor between St Paul and Elias, with the disciples dazzled by the splendour.[5] It is done in an excellent manner and is considered to be one of the most precious things of that land.

For the church of the fathers of San Domenico in Chioggia he painted the Crucifix that spoke to St Thomas Aquinas, saying to him: 'What you have written concerning me you have written well, Thomas.

1. *c.* 1549-50, Vicenza, Pinacoteca di Palazzo Chiericati 2. Destroyed 3. Domenico Tintoretto, *c.* 1588; Bologna, Pinacoteca Nazionale 4. *c.* 1575-80, with workshop assistance, Bologna, Pinacoteca Nazionale 5. Domenico Tintoretto, *c.* 1590, Brescia, Sanctuary of Sant'Angela Merici

With what can I repay you?' and responded: 'With nothing other than yourself, O Lord.'[1] For the Compagnia della Croce in Cividale in Belluno he painted two works with life-size figures of Christ, one depicting the Agony in the Garden[2] and the other Christ before Pilate.[3]

In Mirano, in the territory of Padua, in the parish church he painted St Jerome, nude, meditating in a forest; from that likeness radiate emotions that are divine.[4] In Currano, also in Paduan territory, he painted a curious composition showing the Virgin welcomed by Elizabeth.[5]

In the church of San Giovanni [dei Battuti] in Murano he painted the Saviour baptised in the Jordan.[6] And there at the top is God the Father, surrounded by cherubim and infant angels and finely clad larger angels who serve at the holy office, holding His sacred robes and the white linen to dry Him.

Tintoretto also painted many things at the request of princes and lords. Of these we will mention only the most important. For the rooms of the Emperor

1. Workshop, *c.*1585-94; in situ 2. Destroyed 3. Domenico Tintoretto, *c.*1590; Belluno, Museo Civico 4. Possibly workshop or a follower, in situ 5. Unidentified 6. Domenico Tintoretto, *c.*1590, Murano, San Pietro Martire

Rudolph II he painted four mythologies. In one there is a Musical Concert,[1] with the Muses in a garden playing various instruments. In another Jupiter brings to Juno's breast the infant Bacchus, born of Semele.[2] The third is of Silenus, who comes in the dark to the bed of Hercules thinking to possess Iole;[3] and in the fourth there is Hercules, adorned with female lasciviousness by the same Iole, looking at himself in a mirror.[4]

For Philip II, King of Spain, he painted eight varied poetic themes which that great monarch much admired as works of a happy genius. Tintoretto received the commission from the King's ambassador in Venice. For Guglielmo, Duke of Mantua, besides the friezes which we have already mentioned, he painted his portrait and that of many princes of the family.[5] These portraits were passed on from generation to generation by those princes, who were lovers of painting.

In the gallery of the King of England there are many of Tintoretto's paintings collected at great expense by that magnanimous monarch. One is of Our

1. Possibly workshop, c.1580; Dresden, Gemäldegalerie 2. *Origin of the Milky Way*, 1577-79, London, National Gallery, ill. overleaf 3. Possibly Domenico Tintoretto, *Hercules Ejecting the Faun from the Bed of Omphale*, c.1575-80. Budapest, Szépművészeti Múzeum. Incorrectly identified by Ridolfi 4. Untraced 5. Untraced

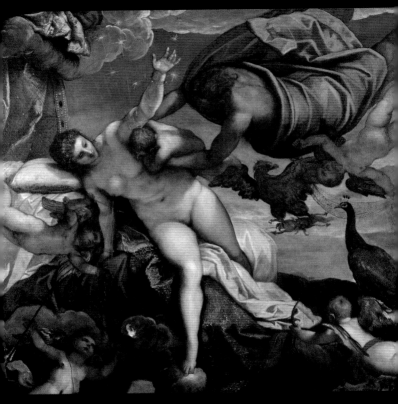

Origin of the Milky Way, 1577-79

Lord washing the feet of His disciples.[1] Two contain mythological subjects, one being the Bath of Callisto; both are highly celebrated.[2]

In the gallery of the Grand Duke of Tuscany there is a magnificently painted portrait of Jacopo Sansovino, the worthy Florentine sculptor, holding his compass;[3] and there is also a very beautiful picture of the Agony in the Garden.[4]

Cardinal Aldobrandino had a half-length picture of Christ Scourged, an admirable figure.[5]

Viscount Basil Feilding, the English Ambassador to Venice, acquired an altarpiece with many saints; another, of the woman taken in adultery, with entire figures of less than life-size; and a small painting of the dead Saviour in the arms of Our Lady;[6] and also many singular portraits, including one of Aretino that seemed as if it spoke.[7]

Monsieur Hesselin, majordomo of the King of France, a few years ago took from Venice for his majesty two great canvases with life-size figures: one a Nativity,[8] and the other a scene of Hell,[9] full of nude bodies, done in Tintoretto's best manner.

1. Unidentified 2. Unidentified 3. *c.*1566; Florence, Uffizi 4. Untraced 5. Untraced 6. Unidentified 7. Untraced 8. Untraced 9. Unidentified

The following works are still to be found with Signori Jan and Jacob van Uffelen: a painting with life-size figures of the Nativity; the portrait of an old beardless man seated, dressed in cloth made of goat's hair cunningly worked in a wave pattern; and another of a Venetian citizen, also very old, with his hand on the belt of his robe; a painting of the Virgin Mary, the Christ Child to whom St Joseph and the Archangel Michael (both life-size half-figures) pay homage; a portrait of a man with a small beard; another head; and among those, one of a little old man with a staff in his hand, whose pose conveys realistically the weight of his years; and also the portrait of a man of advanced age with a long beard wearing a robe trimmed with sable, beside a pedestal, with a book in his hand; a senator with a white beard; and two women, one of whom it is said is the wife of Tintoretto, holding a fan made of feathers, the other of a Venetian matron dressed in red damask, painted in a singular manner.[1]

Likewise we see in the house of Signor Nicolò Corradino a half life-size Risen Christ, and a richly coloured portrait of a youthful student wearing a cap and with a book under his arm.[2]

1. All unidentified 2. Unidentified

Opposite: Portrait of a White-Bearded Man, c. 1555

Pyrrha in Prayer, from the Fables of Ovi

But that is enough of an account of his works outside Venice to show how widely he was esteemed. Now let us proceed to discuss the paintings in Venice in private collections.

In his youth Tintoretto painted a frieze around the mezzanine of the house of the Miani family near the church of the Carità. In it he represented in one part the course of human life, in the other the Abduction of Helen, with other inventions in the other sections. It was painted in the manner of Bonifacio de' Pitati and Schiavone, with both of whom he had practiced.[1]

For the Signori Conti Pisani of San Paternian he painted in the panels of the mezzanine many fables of Ovid.[2]

In the parish of Sant'Eustachio, called San Stae, in the house of Signor Giovanni Pesaro, Cavalier and Procurator of St Mark's, he executed the Four Seasons on gilded leather.[3] For Spring he represented the delights of that season, showing lovely women

1. Unidentified 2. 1541-42; 16 *Fables of Ovid* (only 14 survive) commissioned by Vittore Pisani. Modena, Galleria Estense; one ill. opposite 3. Untraced

Overleaf: The Abduction of Helen, c. 1578

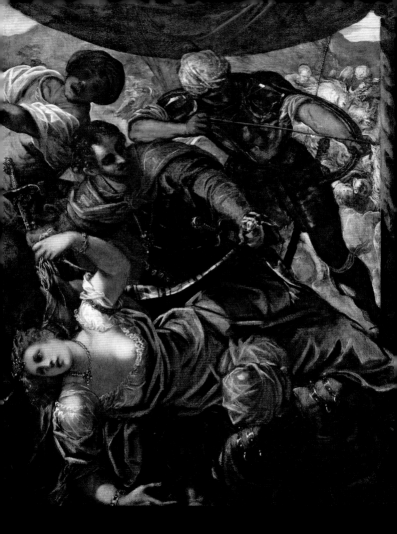

in gardens, varieties of flowers, birds, and hunters with dogs. For Summer he portrayed the work done by peasants in gathering up the crops and bringing in the harvest on carts. There are long colonnades drawn in perspective with gracious views of arbours and palaces. For Autumn he shows several Bacchantes intermingled with delirious youths wreathed with vine leaves and grapes, dancing in a circle to the sound of cymbals. For Winter he portrayed several rites followed by the ancients in that season.

In the ceiling of a room he devised three mythological scenes: Apollo, with the Muses, playing the lyre in the centre; Jupiter and Semele; and Adonis leaving Venus as she attempts to detain him with caresses.[1]

In the museum of Signor Cavalier Gussoni, a senator with a good understanding of painting, we admire (besides the many excellent pictures) the figure of St Mark in a graceful pose writing his gospel; a portrait of a woman dressed in the antique manner, with slashed sleeves, adorned with ornaments, coloured softly; and two portraits of old men. There are also two small narrative paintings, one of Cain killing Abel in a capricious act; in the distance we see God rebuking the wicked brother for his sin.[2] The other

1. Untraced 2. All lost, or unidentified

shows St Paul being converted by the voice of Christ.[1]
As he falls from his horse we see his followers scattered
in fright in many directions, all represented in such
graceful poses that one cannot imagine a finer com-
position. Among the works of Tintoretto it is indeed
a gem among gems.

Signor Cavalier Lando, Senator, connoisseur, and
lover of painting, has among the many excellent pic-
tures by celebrated authors that adorn his rooms three
portraits of his ancestors that are among the most sin-
gular of Tintoretto's work.[2]

Among the paintings in the possession of Signor
Procurator Francesco Morosini was a three-quarter
length picture of Our Lady with the Infant and many
saints in a group; a figure of Vulcan as a smith, life-
size, very skilfully done;[3] a small canvas of St Law-
rence on the grille, done in a very bold manner.[4] It
was painted by Tintoretto for the Bonomi altar in San
Francesco della Vigna. But not understanding its high
quality and believing it to be unpleasant to look at,
they imprudently made an unhappy exchange for a

1. Possibly Tintoretto (or Schiavone?), *c.*1544; Washington, DC,
National Gallery of Art 2. Unidentified 3. Neither identified
4. Possibly, *c.*1575, private collection

Overleaf: The Conversion of St Paul, c.1544

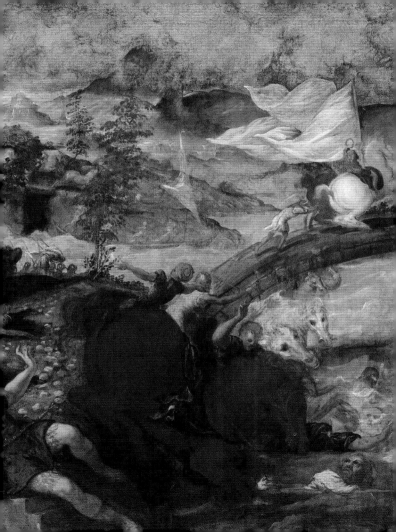

similar subject with minute figures by Girolamo da Santa Croce; Tintoretto's drawing for the painting is still owned by his heirs.

In the house of Signor Nicolò da Ponte, a learned senator, one admires the Portrait of the da Ponte Doge, which is perhaps one of the most vivid and well-executed heads that Tintoretto painted.[1] There is also a very devout image of the Virgin with the Christ Child whom she caresses;[2] and a sketch of the Council of Trent in which the artist represented the group of prelates gathered in session.[3] There too one finds the Doge as the ambassador of the Venetian Republic.

The senators Carlo and Domenico Ruzzini are owners of a flourishing studio filled with many statues, antique heads, a quantity of medals, carved gems, and other curiosities. Among their many excellent paintings are several by Tintoretto: the Miracle of the Loaves and Fishes;[4] the Flight of the Virgin into Egypt; the effigy of the Virgin; Apollo crowning poets with laurel wreaths; and another in which Apollo

1. Possibly Domenico Tintoretto, c.1585, Prato, Museo Civico 2. Unidentified 3. Workshop (or follower), 1580s-1590s, private collection 4. Possibly with workshop assistance, c.1540-50, New York, Metropolitan Museum of Art; ill. pp. 132-33

appears as a shepherd near Anfriso playing the lyre as many listen and Juno gives to the people gems and gold.[1]

In the new quarters of Signor Cavalier Alvise Mocenigo, the senator, which are adorned with various paintings by modern artists and rich ornaments, there is a portrait of the Dogaressa Loredana Marcello,[2] the wife of Doge Alvise Mocenigo. And in the house of Signor Tommaso Mocenigo is the portrait of Henry III, King of France and Poland which we have already mentioned;[3] and also a portrait of the aforesaid doge; and shown adoring the Queen of Heaven in a long canvas are the same doge and his wife, together with other senators and children of the same family, who are depicted as music-making angels at the feet of Our Lady.[4] Signor Lorenzo Dolfin, the senator, has a portrait of a woman and six paintings of Old Testament themes that are used as overdoors. They include Adam and Eve; Hagar and the angel who points to her forehead; Lot with his daughters who, after having fled the fire, give him

1. All unidentified 2. Untraced 3. Untraced 4. *c.* 1578; Washington, DC, National Gallery of Art, ill. overleaf

Overleaf: Doge Alvise Mocenigo and Family before the Madonna and Child, c. 1578

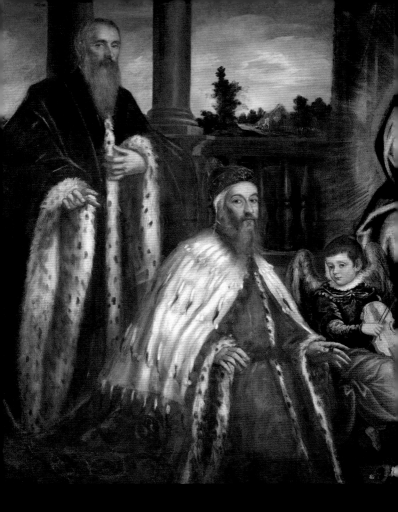

drink; Abraham held back by the angel as he is about to sacrifice his son Isaac; Susannah in the garden[1] with the two old men peeping out of a pergola in the distance; and Boaz sending Ruth to gather the alien corn.[2] Signor Pietro Correr, the senator, has a most lovely invention of St George killing the Dragon, with the daughter of the King fleeing in terror; and there are some dead bodies, beautifully formed.[3]

Signor Ottaviano Malipiero, the Senator, and his brothers are happy to have several very life-like portraits of their ancestors.[4] Other portraits are owned by Signori Francesco and Girolamo Contarini, in particular a very realistic image of a woman of majestic aspect, dressed in sky-blue.[5] Signori Domenico and Alvise Barbarigo possess, besides the many celebrated works by Titian and other authors which we have described, two portraits of illustrious men of their house; Sebastiano Venier, who was later a doge, in the uniform of a general;[6] an oval of Susannah nude in the garden being aided in her toilet by servants, as

1. Possibly Domenico Tintoretto, 1580s, Washington, DC, National Gallery of Art 2. Unidentified 3. *c.*1553-55, London, National Gallery; ill. opposite 4. Unidentified 5. Unidentified 6. *c.*1571, Vienna, Kunsthistorisches Museum

Opposite: St George and the Dragon, c. 1553-55

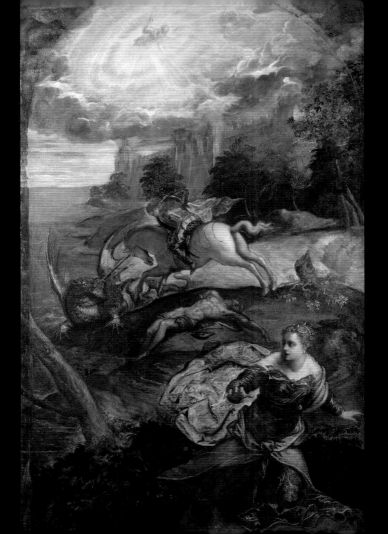

well as the two old men who are attracted to her and admire her from a hiding place, and some animals also are included; and there is a small capriccio of the Muses in which Tintoretto showed his skill.[1]

Signor Vincenzo Zeno, whose pastime of playing brushes and colours deserves much praise, possesses a picture of the Virgin with Our Lord as an infant and has also from property settlements some family portraits.[2] He owns as well two pictures about three *braccia* each. One is of the Triumphant Saviour entering into Jerusalem on a donkey;[3] in front of Him are some Hebrews carrying olive and palm branches, while others as a sign of homage spread their cloaks under His feet. The other picture, skilfully executed, is of the woman taken in adultery, as Our Lord points with his finger at the letters written on the ground; we see the scribes and pharisees one after another leave, concealing themselves behind the columns of a colonnade that forms a splendid perspective.[4] In the Grimani house in the parish of San Luca we see in a great canvas the Magdalen at the feet of the Redeemer weeping for her sins.[5] In the Foscarini house at the

1. Untraced 2. *Vincenzo Zeno, c.*1565, Florence, Palazzo Pitti 3. Possibly workshop, or Giovanni Galizzi, *c.*1565, Florence, Palazzo Pitti 4. Giovanni Galizzi, *c.*1565, Rome, Palazzo Barberini 5. Unidentified

Carmine there are also two canvases, a Resurrection of Christ and other devotional subjects.[1] The Signori Mocenigo at the Carità have a small picture of Herod with his henchmen and his sister-in-law at table when her daughter appears bringing the head of St John the Baptist to the wicked mother.[2] In the house called the big house of the Corner family we see in one of the rooms, along the frieze, the departure of Queen Caterina Corner from the isle of Cyprus;[3] there on the beach are represented the troops of cavaliers and ladies who attend her as she boards the galley on the arm of her brother. And in the Barbo house at San Pantalon in the panelling of a room we see a dream sequence with some goddesses in the sky and various images of the things produced in the minds of mortals in their sleep;[4] in the surrounding area the Four Seasons are personified.[5]

The Signori Navagiero at the Pietà have the portraits of Bernardo and Andrea Navagero, the celebrated poets;[6] and in the da Mula house at San Vio

1. Unidentified 2. Unidentified 3. Untraced 4. *Allegory of the Dreams of Men*, *c.*1548, Detroit, Institute of Arts, ill. p. 60 5. *c.*1546-48: *Spring*, Norfolk (Virginia), Chrysler Museum; *Summer*, Washington, DC, National Gallery of Art, ill. overleaf; *Autumn*, private collections; *Winter*, lost or untraced. 6. Unidentified

Overleaf: Summer, c. 1546-48

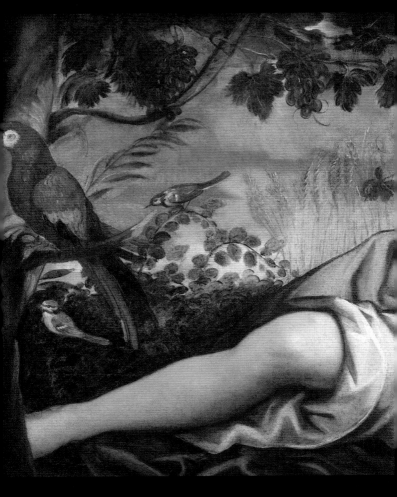

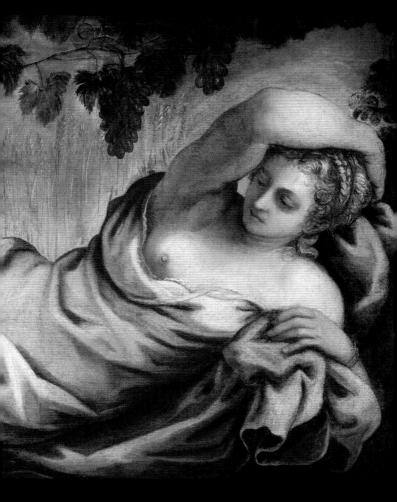

there is a caprice of the Muses with Apollo in their midst playing his lyre;[1] and in the Ca' Priuli at Santa Maria Nuova is seen a nude life-size St Jerome.[2]

The Counts Widmann have two excellent paintings by Tintoretto: one depicts Christ baptised by St John in the Jordan,[3] and the other shows the woman taken in adultery being brought by the scribes and pharisees into the presence of the Saviour, in whose face we perceive a beauty without sin that enraptures the heart.[4] Both paintings were executed in such a strong and bold manner that one could scarcely see on canvas more strongly modelled figures. Signor Alberto Gozzi has a Last Supper.[5]

Most singular, however, is a long picture that we admire in the previously mentioned gallery of Signor Cavalier Jan Reynst of full-length portraits of the Pellegrini family,[6] seated with some matrons at a garden table, with their young children, also life-size, coming in from the hunt with dogs and servants, carrying hares. Besides the beauty and excellence of its colouring it forms a noble and rare composition. In

1. Unidentified 2. Unidentified 3. Untraced 4. Possibly Domenico Tintoretto, *c.* 1585, Copenhagen, Statens Museum for Kunst 5. Unidentified 6. Possibly workshop (or a follower), 1570-80, private collection

this same gallery, together with the paintings already described, there are also to be seen many pictures with original inventions, diverse landscapes, and other things by the most celebrated painters of our age.

Signor Nicolò Crasso, the renowned jurisconsult, has a small canvas of Hercules furiously casting away Silenus, who had imprudently entered his bed in the dark, thinking to enjoy Iole.[1] She and one of her maid-servants, awakened by the noise, display their very exquisite bodies, while another servant who has hurried there with an oil lamp throws light on the scene. He has, as well, the portrait of Sebastiano Venier, skilfully done;[2] a self-portrait of Tintoretto in his youth;[3] the head of St John the Baptist on a platter; the portrait of Maffeo Venier, the celebrated poet; and also one of his family.[4]

Signor Francesco Bergonzi, a gentleman in whom the most virtuous qualities contend, possesses a very life-like portrait of a man of middle age who with one hand holds closed a coat of marten fur and in the other hand holds a handkerchief; he looks straight

1. Unidentified 2. Possibly with workshop assistance, c. 1571-77, Turin, Galleria Sabauda 3. c. 1546-47, Philadelphia, Museum of Art; or London, Victoria and Albert Museum (by Domenico Tintoretto); ill. p. 9 4. Unidentified

ahead with an expression of natural dignity.[1] As a demonstration of his delight in and understanding of painting, he has collected not only the excellent works described in the lives of the painters of the past, but also those of the modern painters who are esteemed. Thus he has a Susannah at the bath by Alessandro Varotari; a half-length figure of St Jerome with a skull in his hands by Jusepe de Ribera, called Spagnoletto; a Lot with his daughters by Johann Liss; another figure by Daniel van den Dyck; some noble parables by Domenico Fetti; two caprices by Pieter Bodding van Laer, called Bamboccio; as well as many landscapes and other paintings which we will mention in the lives of the artists which we will subsequently write.

Signor Nicolò Renier [Nicolas Régnier], an excellent painter mentioned elsewhere whose merit was made known by many rare portraits and other works he painted in Venice and elsewhere, also has a painting by that industrious hand representing an Adoration of the Magi with less than life-size figures, formed with the highest grace and design of the rarest invention;[2] and one of the most curious creations of that genius, a life-size Susannah at her bath.[3] One

1. Unidentified 2. Unidentified 3. c. 1555; Vienna, Kunsthistorisches Museum, ill. pp. 210-11

of the old men, who is lying on the ground, hidden among some foliage (very skilfully done), watches her, and from the garden his companion looks out furtively. Renier acquired numerous paintings which together form a singular collection. Among the other works we see a St Jerome of average size meditating on the crucified Christ, a singular work by Antonio da Correggio; a portrait, in a very mannered style, by Leonardo da Vinci; Christ led to Mount Calvary by the executioners, the work of Lorenzo Lotto; a large painting, by Paolo Veronese's hand, of Judith who, having cut off the head of Holofernes, is handing it to her old servant, a work in which decorum is joined with beauty. Words cannot describe the marvellous force of the figure of Judith and her disdain for the disordered bed with the remains of the captain. Another with the figure of St Jerome, larger than life and with a lion at his side that appears to roar, is by Peter Paul Rubens; and there is a small canvas by the same Rubens of Mars armed with sword and shield treading on some vanquished figure as Bellona hands him the thunderbolt and Victory a wreath of laurel. There is also a life-size half-figure by Guido Reni of Cleopatra, who has been wounded in the breast by

Overleaf: Susannah and the Elders, c. 1555

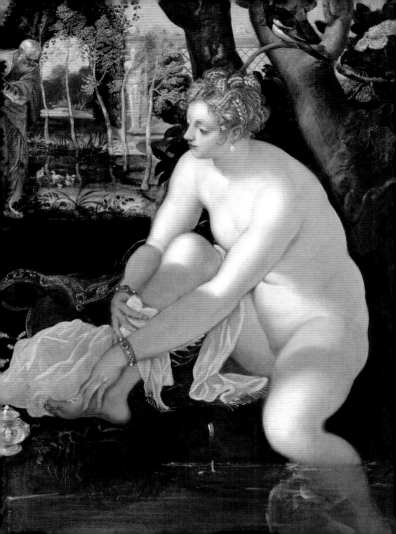

CARLO RIDOLFI

the serpent and, swooning with pain, seems to die lit-
tle by little; and there is Apollo flaying Marsyas, also
life-size, by the same hand, and in his best manner.

Monsignor Girolamo Melchiori [Marchiori], rec-
tor of Santa Fosca, admirer and protector of painters,
likewise has among his famous paintings a singular
portrait by that author.[1]

Signor Paolo del Sera, a Florentine gentleman and
a student of painting, acquired the portrait of a Vene-
tian senator, which is so natural that he seems alive;[2]
and Signor Paolo Rubino has in his house a painting
with small figures in the manner of Schiavone.[3]

In the dining hall of the Fondaco dei Tedeschi, Tin-
toretto, in competition with other painters, executed a
life-size allegorical representation of the Moon seated
on a gilded chariot armed with a bow and arrows,
adorned with billowing veils and other charming dra-
peries. With her are the Hours who gracefully pour
dew from silver urns onto the flowers.[4]

In the rooms of the Procuratia are also seen many
portraits of procurators of Saint Mark's and of the

1. Unidentified 2. Unidentified 3. Unidentified 4. *Luna and the
Horæ, c.*1580-85. Formerly Kaiser Friedrich Museum; lost in bomb-
ing (1945)

Opposite: A Procurator of Saint Mark's, c. 1575-85

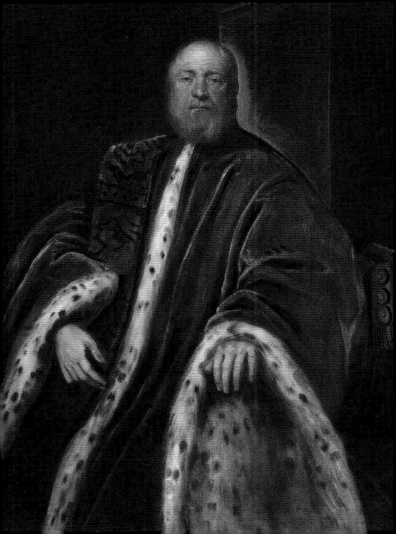

doges,[1] done with such fresh and vivacious colours that they seem to be alive. Students can learn from them how to colour and to arrange a portrait in many different ways; and in the Procuratia de Supra there is the figure of the Dead Christ in a lunette.[2]

In one of the rooms of the Avogaria he designed a long picture of the Redeemer, surrounded by luminous radiance, rising from the sepulchre, with three magistrates kneeling beside Him; and two pictures of the same composition, one in the Sala Vecchia of the Doge, the other in the room next to the Pregadi, are both executed with the greatest delicacy.[3]

In the Magistrato al Sale he painted many portraits of senators, some of whom are adoring the Queen of Heaven.[4] In one of the series he painted St Theodore, St Margaret, and St Louis in bishop's vestments, graciously posed.[5] In another he painted St Andrew leaning on the cross while St Jerome, holding a book,

1. Untraced 2. 1562-71, with workshop assistance; Milan, Brera 3. *Resurrection with Three Avogadori and Two Notaries* (fragment), *c.*1571; *Return of the Prodigal Son*, *c.*1575-76; both with workshop assistance, in situ 4. *Virgin and Child with Four Provveditori*, with workshop assistance, 1553; Venice, Istituto Veneto 5. *Sts George and Louis of Toulouse, and the Princess*, 1552, Venice, Accademia. Incorrectly identified by Ridolfi

Opposite: Sts George and Louis of Toulouse with the Princess, 1552

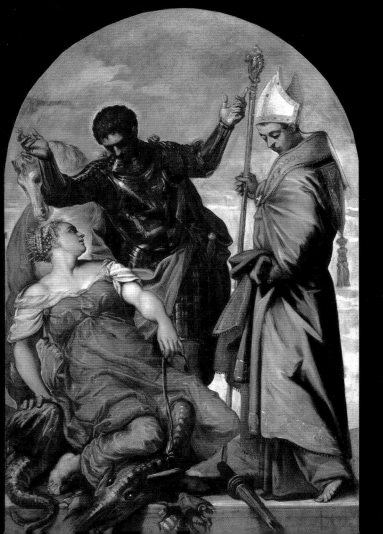

speaks with him.[1] In the Camerlenghi he portrayed also in a long canvas the Virgin with senators before her in reverent attitudes and servants behind bringing sacks of money.[2] In the neighbouring spaces appear the Saviour, St Mark, and Venice, as well as portraits of gentlemen of the Camerlenghi.[3]

Many other paintings by Tintoretto are also to be seen in the houses of Venetians. In particular there are some of very beautiful colour that belong to Signor Giovanni Grimani. One of Giovanni Paolo Corner, called the Antiquarian, in which he rests his hand on a statue, belongs to the Signori Zaguri.[4] Signor Jacopo da Ponte, jurisconsult, has one of a man robust in aspect and very vivacious; and Don Antonio dei Vescovi has the portrait of Franceschina Corona, the wife of Pietro de' Benedetti, doctor, which Tintoretto painted in competition with one by Titian of Benedetti, and which is described elsewhere. Don Lelio Orsini carried to Rome the portrait of Camilletta Dall'Orto, a Venetian noblewoman, a work of masterful ease and grace that was formerly in the painting collection of

1. 1552, Venice, Accademia 2. *Madonna of the Treasurers*, 1567, Venice, Accademia 3. *c.*1571, with workshop assistance, Berlin, Gemäldegalerie 4. 1561; Ghent, Museum voor Schone Kunsten, ill. opposite

Opposite: Portrait of Giovanni Paolo Corner, called the Antiquarian, 1561

Aliense, a renowned painter. Another painting, a portrait of a monsignor, enhances the decoration of the studio of the brothers Muselli, the Signori Cristoforo, jurisconsult, and Francesco, most worthy patricians of Verona.[1]

But those we have mentioned will suffice to show how worthy Tintoretto was in these things as well.

Finally, let us gather some of the fruits of his last years, which are not lacking in grace and beauty. In his work he followed the natural order of things, which tends to greater vehemence toward the end, and thus up until the end of his life he tirelessly painted, producing effects always corresponding to his great talent.

For the Confraternity of the Rosary of Santi Giovanni e Paolo, which was given a sumptuous new building by Venetian merchants to commemorate the victory over the Turks in the year 1571 (and embellished with precious statues by Alessandro Vittoria, who was the architect, as well as by Girolamo Campagna), Tintoretto painted in the centre of a great oval the Virgin giving the dispensation for the Rosary to Sts Dominic and Catherine of Siena.[2] Below are the major Christian princes who await that devotion,

1. Unidentified 2. Lost in a fire (1867)

and in some of the smaller spaces he painted beauti-
fully garbed angels who scatter flowers as a sign of
joy.

On the walls he represented the Massacre of the
Turks by the Christian army through the intercession
of the Most Holy Virgin at the summit together with
St Justina, who speaks to her. In that small canvas he
depicted the battle with a great number of galleys
and figures of every description. Opposite the altar
he painted the Crucifixion with Our Lady swooning
at the foot, accompanied by the Maries and the Mag-
dalen, who clings to the cross with much emotion;
the bodies of many saints arise from the tombs as it
says in the Scriptures, and a soldier with a very fero-
cious gesture breaks the legs of one of the crucified
thieves.[1]

In San Giorgio Maggiore we see four altarpieces.
In one of the two larger ones, which are in the tran-
sept chapels, we see the Stoning of St Stephen, with
a quantity of figures;[2] in the second he depicted Our
Lady assumed into Heaven, crowned by the Eternal
Father and His Son, while beneath on clouds are

1. Both lost in a fire (1867) 2. Domenico Tintoretto, *c.*1593-94, in
situ 3. Domenico Tintoretto, *Coronation of the Virgin*, *c.*1593-94, in
situ

some of the beatified of that Order.[3] In one of the two minor altars there is a picture of the Saviour rising from the sepulchre, together with portraits of the Morosini family;[1] in the other there are martyrs being tortured in many ways;[2] and in the predella some of their relics are preserved. In the Chapel of the Dead [Cappella dei Morti] of the same convent, he painted the Redeemer taken down from the Cross.[3] In view of the graceful mastery of form and composition in the painting, it is appropriate to honour it as a heavenly work. A little distance away on a hill the Virgin in agony is surrounded by her compassionate sisters who try by loosening her bodice to revive her. Even though Tintoretto was in his final years his mind was still active. In this work especially he showed that his brush was not lacking in ability to produce his usual marvels.

Then on the sides of the main chapel of the church itself he painted two large pictures. On one side is the Miracle of the Manna[4] and on the other the Last Supper with Christ and the Apostles.[5] The table is seen from a bizarre angle and lit by a lamp hanging in the middle.

1. *c.* 1586, with Domenico Tintoretto; in situ 2. *Martyrdom of Sts Cosmas and Damian*, with Domenico Tintoretto; in situ 3. 1592-94, with Domenico Tintoretto; both in situ 4. 1592-94, with Domenico Tintoretto; in situ 5. 1592-94, with Domenico Tintoretto; in situ

By order of the Senate he painted two altarpieces for the new church of the Capuchins, of which the better one is that of the Flagellation.[1] And in the Madonna delle Grazie, in the lagoon, he painted on the organ shutters the Virgin Annunciate, the Resurrected Christ, and St Jerome in prayer.[2]

He also made many cartoons for the mosaic masters of the church of St Mark. The most remarkable are the two in the barrel vault of the apse, one of the Last Supper[3] and the other a Marriage at Cana[4] in which the figure of the steward who indicates with his hand the pitcher of water changed to wine is especially admirable.

But we are approaching the end of this great author's works, since to claim to gather together all the things he painted would be empty, and we will speak briefly of the Paradise, that great work that he painted in the Hall of the Great Council, with which he gloriously crowned his great career.[5] The Senate decided that, in addition to the paintings that were renewed in the Hall of the Great Council, the Paradise Guariento

1. Domenico Tintoretto, *Ascension of Christ*, and *Flagellation of Christ*, c. 1590, in situ 2. Untraced 3. 1568, with Domenico Bianchini, in situ 4. 1568, with Bartolomeo Bozza; in situ 5. 1588-92, with Domenico Tintoretto, in situ; ill. pp. 224-26 and details from a sketch on p. 14 and p. 227

had painted before the fire of which we spoke previously should be repainted. Having decided on those innovations, the Signori debated at length the choice of the artist, since opinions were still varied after having seen many models. Finally one of the groups prevailed, and it was decided that the commission would be entrusted jointly to Paolo Veronese and Francesco Bassano. But since their styles did not harmonize, and also as Paolo died soon afterwards, before either of them had begun the work, it was necessary to have a new election. But although able painters again strove to obtain the commission, it was finally given to Tintoretto, who on his part had not failed to use every trick in order to get it. Talking at times with the senators he used to say that, being already old, he prayed to Our Lord to grant him Paradise in this life, trusting in his mercy to also obtain it in the next. His selection, however, was facilitated by the word spread by his friends that no one else was suitable for that work but Tintoretto.

For the composition he made numerous oil sketches. In one of these, which is preserved in the house of the Counts Bevilacqua in Verona, the Blessed are divided into many circles.[1] In the end he was satisfied

1. *c.*1577, Paris, Musée du Louvre, details ill. on p. 14 and p. 227

with the composition which we see today, although he changed some parts of it, since those who have an abundance of ideas find it difficult to be content with their first concept. He then set to work on that great canvas, thirty feet high and about seventy-four feet long,* stretching it out in several parts in the Scuola Vecchia della Misericordia, which was a place suitable for so vast an enterprise. Here the good old man devoted himself to translating the model into the finished work, not sparing any effort in cancelling and redoing that which did not turn out to his taste, and availing himself of real objects in those cases where it seemed to him necessary for approximating life, such as the habits of the saints of the various religious orders and also effigies of Virgins and the Blessed. He used live models for those things that are useful to the painter, as in observing the joints of the limbs and the appearance of the muscles in bodies under stress. But the development of the composition, the poses of the figures, the boldness of the contours, the convolutions of the garments, the clothing of the figures in a graceful manner, and finally, the brightness of the colours—all this comes from the long study and experience of a master painter.

* Actual measurexment 7 x 22 m (= about 20 x 64 Venetian feet)

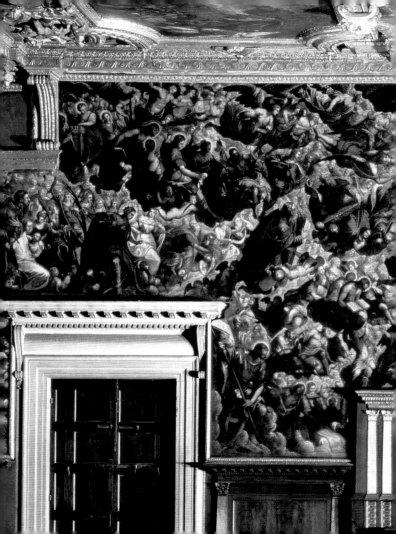

The composition being laid out and brought to some perfection, he put it in place in the Sala del Consiglio in order to see the effect it would have. Thus with all the parts of the canvas together he set out diligently to give it the final touches. But lacking the strength for the work (being bowed down by his years and by those long hours of labour, as well as the occasional need to climb up and down the scaffolding), he had his son Domenico come and help, and Domenico finished many things from the model. According to some, however, he overdid himself in designing decorations and splendours. Nevertheless, Domenico's work was a relief for his father, for he took many tasks from him which had become lengthy and burdensome in his old age.

Considering the vastness of the composition, the countless number of figures it contains, and the admirable way the whole holds together, the mind can find no words by which the pen can express it. It is said that Tintoretto observed the order of the litanies in the placement of the saints, since we see the Virgin in the centre, praying to her Son for the Venetian Republic, and the Angels, Archangels, and Blessed Spirits arranged around the throne of God. He then placed in order the Apostles, Evangelists, Martyrs, Confessors, and Virgins, filling the spaces on each

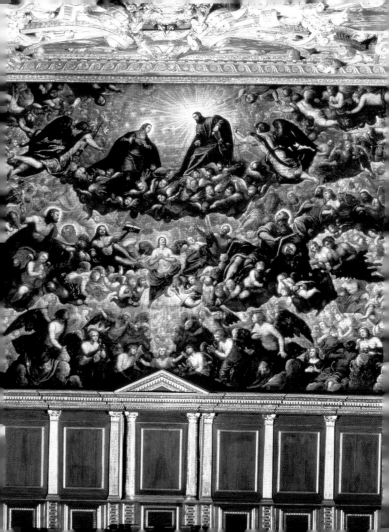

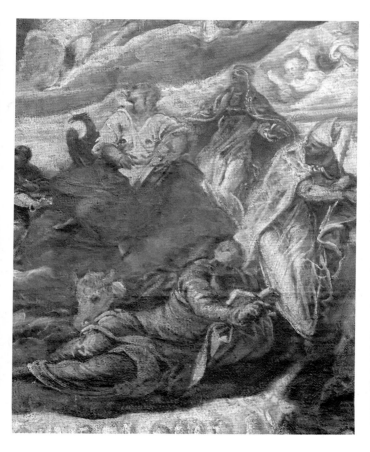

Fold-out: Paradise (with Domenico Tintoretto), 1588-92
Above: detail of sketch for Paradise, c. 1577

side of the encircling clouds with men and women saints of the Old and New Law, and in the middle he placed a number of the Blessed, angels dressed in graceful ways, and nude infants veiled in radiance so as to separate them from the nearby groups. Thus he composed, to the extent that we have an understanding of it, the order and union that is thought to exist in Paradise. It seems an impossibility that the human intellect could arrive at the expression of a concept so grand. Hence it is no wonder that amid the abundance of so vast a number of things the pen fails at its appointed task. At the unveiling of such a rare example of Paradise it seemed to everyone that heavenly beatitude had been disclosed to mortal eyes in order to give a foretaste of that happiness which is hoped for in the life to come as a reward for doing that which is good; and hence the general acclamation. By word of mouth the painting was commended by all. His friends competed in rejoicing with Tintoretto at the appearance of a marvel never again to be seen on earth. The painters themselves, overwhelmed with astonishment, praised such great mastery. The very senators congratulated him and affectionately embraced him for having brought to conclusion that great piece of work to the enormous satisfaction of the Senate and the entire city. The good old man

rejoiced, exchanging happiness for the tedium of the past, his heart's true objective being the praise gained through the merit of his works, for which goal noble spirits will willingly strive.

Being then sought by the Signori who were charged with fixing his compensation, they asked him, after first commending his valour, what recompense for his work would please him, so that they might accede to his request. He responded that he desired only to rely on their favour, and they, in response to his noble manner, assigned him a generous reward. But he, so they say, did not want to accept it, being content with much less, wanting perhaps by this course to capture their affection. This produced a sense of wonderment not only among the Signori, but also among the painters themselves who had privately estimated that that work would bring a great sum.

Such were the ways Tintoretto often adopted in his negotiations, thus arousing the hatred of other painters, since it seemed to them that he damaged the reputation of art by not maintaining the requisite decorum. Whence perhaps some thought that he put so small a value on his paintings because he produced them without effort, although in truth nothing ever came from his hand that had not been fully thought through, or at least brought into its proper form. His

way of working, when not well understood or when learned other than by the means he used, caused small-spirited souls who wanted to follow him but lacked his great foundation in design to end by bringing themselves to grief. Not everyone could fill his shoes. We see by the paucity of good examples how difficult it is to conquer painting and how Heaven rarely bestows similar favours save after the passage of centuries. Every connoisseur knows how small is the number of excellent painters that have flourished from the time of Zeuxis and Apelles, from which it can be deduced how Heaven favoured Tintoretto with special gifts. It is also true, however, that he often abused such a great gift by painting anything that came along. Things that are reduced to the level of the domestic and the familiar greatly debase taste, just as penury increases desire in man; when there is an abundance of the greatest delicacies our nature rejects them. Nor is there any doubt that if Tintoretto had at times restrained his natural intensity, contenting himself with painting a lesser number of pictures, he would surely have gained a greater reputation with those who have little understanding of art. But not wanting anyone to ever leave his house discontented, he tried always to satisfy others and often gave his works away. Thus, burdened with many

commissions, he was unable to finish everything with the same degree of application. For that reason perhaps many pictures that he exhibited were not completely finished, as he attempted by the rapidity of his work to lighten his load. It seemed that after his labours on the *Paradise*, his fury for work slackened, and he gave himself over to the contemplation of heavenly things, thus preparing himself like a good Christian for the way to Heaven. He spent much time in pious meditation in the church of the Madonna dell'Orto and in conversation on moral themes with those Fathers who were his intimates.

He did not completely neglect his painting, however. He executed two large pictures which were placed unfinished in Santa Maria Maggiore. One is of St Joachim,[1] who was expelled by the priest from the temple because he had no children, and the other was the Marriage of the Virgin, a masterful composition.[2] In the same manner he painted the Last Supper with the Saviour and his Disciples and the Agony in the Garden in Santa Margherita.[3] Four medium-sized paintings of the life of St Catherine Martyr were

1. Domenico Tintoretto, *c.*1590; Venice, San Trovaso 2. Domenico Tintoretto, *c.*1590; Venice, Accademia 3. 1576, with workshop assistance; both Venice, Santo Stefano

placed in the church of that name.[1] There is in the Confraternity of the Merchants an altarpiece of the Birth of the Virgin which he worked on while on holiday in his villa at Campenedo.[2] He also painted the shutters of the organ of the Maddalena[3] and also some other things at the request of friends, being unable to do anything less than follow his natural talent.

He also had the idea of making a number of drawings in which he proposed to leave in print some of his fantasies so they might serve as a record of his countless works, but the plan was not fulfilled since the scythe of inexorable death cuts short all human intentions.

It remains for us to speak of his habits in order to satisfy the reader's curiosity in that area as well. This excellent man was so isolated in his thoughts that he lived far removed from all gaiety, thanks to his unceasing work and the weariness that study and diligence in art brings. Those who are immersed in speculation about painting and engaged in continual labour give up pleasure and have no experience of those things which are soft and sweet. The greater part of the time that he was not painting he remained

1. Domenico Tintoretto, 1580s; six paintings, Venice, Palazzo Patriarcale 2. *c*.1590, with Domenico Tintoretto; Venice, Accademia 3. Untraced

isolated in his studio, which was situated in the most remote part of his house, and where in order to see well, he always kept the lamp lit. Here in the midst of an infinity of bas-reliefs he spent the hours meant for repose with the models he used to devise the inventions that he needed in his work. Only rarely did he allow anyone, even a friend, to enter, nor did he ever allow painters, except intimate associates, to see him at work, since the masters always kept the techniques of their excellent disciplines hidden when acclaim is the goal. These techniques the studious acquire only after lengthy observation and toil.

He had, however, a pleasing and grateful disposition. Painting does not make men eccentric, as some think, but makes them aware and adaptable to any occasion. He conversed with great affability with his friends. He was always ready with pleasantries and charming phrases which he uttered with great grace and a noble bearing free from any trace of laughter. When he felt it appropriate he also knew how to banter with the great and, at times, availing himself of the sharpness of his mind, his thoughts found utterance in unexpected ways.

Because his sayings and witticisms are great in number we will only note some of the more remarkable. Asked by Odoardo Fialetti, a young Bolognese

newly arrived in Venice to study, what he should do in order to make progress in his work, he replied that he must draw. Fialetti again asked if he could give him further counsel, and the old man added that he must draw and again draw, rightly deeming that drawing was what gave to painting its grace and perfection.

He was visited by some Flemish youths who had come from Rome and brought with them some of their drawings of heads executed with extreme care in red pencil. When he asked them how much time they had spent on them, some said ten days and some said fifteen. 'Truly,' Tintoretto said, 'you could not have taken less,' and dipping his brush in black he made with a few strokes a figure, touching it boldly with white highlights. Then turning to them he said: 'We poor Venetians do not know how to draw except this way.' They were astonished at the speed with which he created, and realised the time they wasted.

He was commissioned by certain persons to paint a St Jerome in the woods, and, as is the custom, he painted the saint nude with trees nearby. When he showed it to them they said they wanted the saint in and not outside the woods. Tintoretto realised that they wanted to offend him. 'Come back,' he said, 'and

Overleaf: Reclining Male Figure, 1560

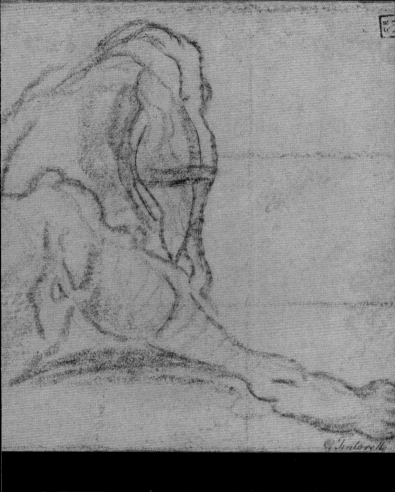

you will find him in the forest' and with colour mixed with common oil he covered him with trees. But when they did not see the figure they said, laughing: 'Where is the St Jerome?' Then he removed the colour, which was not yet dry, with his fingernail and showed them the figure, thus mortifying them.

Some prelates and senators who visited him, seeing how vigorously he applied certain brush strokes while working on the Paradise for the Hall of the Great Council, asked him the reason for doing so since Giovanni Bellini, Titian, and others of the old school were so careful in their works and he on the contrary went about his work so roughly. Without wasting any time he replied: 'Those ancients didn't have, like me, so much noise and chatter to contend with.' Thereupon they dared no longer goad him.

One time, in the lodgings of Signor Giacomo Contarini, where many excellent painters and other worthy persons gathered, a portrait of a woman by Tintoretto was praised, and a fine fellow turned to him and said: 'That is the way one should paint.' It appeared to the old man that the phrase was barbed, and on returning home he took a canvas on which was painted a head of a woman by Titian. On the other side he painted a young girl, a neighbour of his, and darkened it a bit with smoke and covered the

other portrait with gouache. Taking it to the usual gathering he showed it around and everyone studied it, praising it as something singular by Titian himself. At which point Tintoretto removed the colour from the first portrait with a sponge and said: 'This, yes, is by the hand of Titian, but the other I painted. Now, gentlemen, you see how much weight judgment, authority, and opinion have and how few there are who understand painting.'

His brother who lived in Mantua questioned him in a letter about many things and at the end asked whether their mother, who had been ill, had died. In order to finish the task quickly Tintoretto laconically replied, 'Dearest Brother, the answer to all your questions is No.'

When he was painting the portrait of a prince from beyond the Alps and saw no sign of compensation, he learned from one of his courtiers how one asked for money in his language. When a good opportunity arose he asked this of the prince, who on his part entrusted his majordomo to generously reward him.

One time he was summoned by a Venetian noble to paint a certain picture in fresco in one of his gardens, and having to take the measurements of the wall he quickly stretched out his arms and measured

the space. On being asked how much it was he said: 'Three Tintorettos.' When he left his house, Donna Faustina Episcopi, his wife, was in the habit of tying a certain small sum of money in a handkerchief, saying that on his return he must give a minute account of his expenditures. But he, amusing himself with gentlemen, spent his money merrily. On being asked by his wife about his expenditures, he gave her to understand that he had spent his money on charity for the poor and imprisoned.

He found himself at one point in a villa where he had gone to paint in fresco. The gentleman of the house from time to time left him in the company of one of his beautiful ladies while he went off to Venice on business. He was therefore often importuned by the same lady as to what this or that figure meant. In order to rid himself once and for all of the annoyance he said to her: 'Signora, have dinner prepared: then, if you like, I will come this night to sleep with you and give you five ducats.' The good woman willingly accepted the terms and, having dined, she went to bed with him. But the poor old fellow, exhausted from the labours of the day, could scarcely raise a feeble lance and went to sleep for the rest of the night. Getting up early the next morning, without a word to her he returned to

his usual activity. Waking from her sleep, the woman was astonished at not finding her lover, but saw the agreed upon payment on the table. At this point full of indignation and by now dressed, she quickly went to where he was painting and began to lament about the short stay of her amorous cavalier, and of the disdain he showed in leaving her bed without even saying goodbye. But he, after enduring for a short time the importunity of the woman, finally said to her: 'Be satisfied, Signora, that I did not fail in my word. But if I were to tell the truth, I have at times enjoyed with less expense some poor girl who was better than you are.' Thus he shamed the pretensions of the courtesan, giving her to understand that he had paid for her services and not for her person, as often happens also in painting.

One time a merchant, charmed by a certain figure of the Magdalen that had been done by Tintoretto's son Domenico, persuaded him with his entreaties to sell it to him, promising him after much negotiating to pay thirty ducats. Since it seemed to Tintoretto that a fat profit would be realised, he finally sold it to him. But Domenico, on returning home and going through his paintings and not finding it with the others, made

Overleaf: The Mystic Marriage of St Catherine, c. 1545

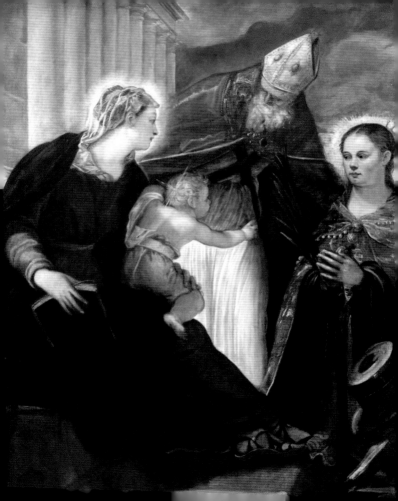

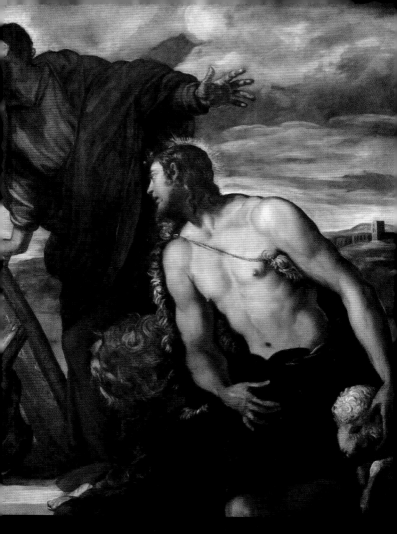

a terrible uproar that increased when he heard that his father had sold it. Thus Tintoretto was forced, in order to have peace, to beg for the return of the picture, saying he would pay back the money or give him another by his own hand. Nevertheless he railed at Domenico for his lack of sense, complaining that he had never had such luck with one of his own pictures.

A witty fellow came to see him one time and said that, having heard how famous Tintoretto was, he wanted to be painted by him. He admonished him, however, to paint him in some extravagant pose, as he was a beast of a man. Tintoretto quickly responded: 'You should go to Bassano. He will paint you in your natural state.'

Asked his opinion about a painting which included men, animals, and landscapes, he said: 'I like everything but the figures.'

Pietro Aretino, part of the Titian faction, spoke ill of Tintoretto, who resented it, and one day on meeting him Tintoretto invited him to his house in order to paint his portrait. Aretino went and when he took his seat, Tintoretto, in a fury, drew a dagger [or *pistolese*] from under his robe. Aretino, who was frightened and feared that Tintoretto was going to settle the score, started shouting: 'Jacopo, what are you doing?' Tintoretto answered: 'Calm yourself. I just want to

measure you.' Beginning with his head and proceeding down to his feet, he said: 'You are two and a half daggers long.' Aretino, his spirits calmed, said: 'Oh, you are a great lunatic and are always playing tricks.' However, he no longer dared to slander him and became friends with him.

On his return from a certain city in Lombardy he was asked by Jacopo Palma Giovane what he thought of the painters there. He replied: 'My *alter* Jacopo, I don't know what to say, except that they are all in the dark.'

He used to say that the study of painting was hard and the more one got into it the more difficulties arose and the sea always grew more vast.

He said that young students should never stray from the path of the finest artists if they wanted to get ahead. In particular he recommended Titian and Michelangelo, the one marvellous in draftsmanship, the other in the art of colouring, and that Nature was always the same, and that one should not alter the muscles of the figures capriciously. What would he say if he returned today to see men instructed in the painting now in vogue?

He also said that in making a judgment of a

Overleaf: The Supper at Emmaus, c. 1540-45

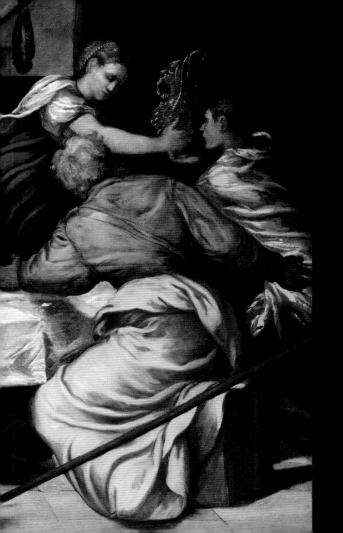

painting one ought to note whether the eye was satisfied at first glance, and whether the artist had observed the precepts of art, but that in so far as details were concerned, everyone made errors. He further said that when exhibiting works in public one should wait for many days before going to see them, since by then all the darts would have been thrown and people would have become accustomed to them.

Asked which were the most beautiful colours, he said black and white, because the one gave strength to the figures, by deepening the shadows, and the other provided the contrast. He said also that drawing from live models was only for those who were expert since for the most part human bodies lacked grace and good form.

Having seen some drawings by Luca Cambiaso of Genoa that had recently been making the rounds, he said they were enough to ruin a youth who did not possess a good foundation in art, but that a good man with experience in the profession could draw profit from them as they were full of learning. He also said that beautiful colours were sold in the shops of the Rialto, but that design was drawn with much study and long hours from the mind's treasure store, and for that reason it was understood and practiced by few.

He also invented bizarre caprices of dress and

humorous sayings for the representations of the comedies that were put on in Venice by young students for amusement. For these productions he created many curiosities that amazed the spectators and were celebrated as singular. Because of this everyone applied to him on like occasions.

In his youth he took pleasure in playing the lute and other strange instruments of his own invention, thus in every way departing from the common usage. He dressed like a gentleman in conformity with the custom of his time, but when he reached a mature age, with the encouragement of his wife, who held the rank of citizen of Venice, he wore the Venetian toga. Thus it was that his lady used to watch him from the window when he went out in order to observe how well he looked in that dress. But he, instead, in order to annoy her, showed little regard for it.

Among his friends and intimates were the principal Venetian nobles and learned men who lived in the Venice of his time: Daniele Barbaro, the Patriarch of Aquileia, Maffeo Venier, Domenico Venier, Vincenzo Riccio and Paolo Ramusio, Secretaries of the Senate, Bartolomeo Malombra, Lodovico Dolce, Pietro Aretino, and many others. Nor was there a fine mind that did not make use of his skill and have his portrait painted by him. They include, among others, Giovanni

Francesco Ottobon, the Grand Chancellor of Venice illustrious for his writings and for his extraordinary memory, whose splendid portrait is admired in the house of Signor Marco Ottobon, the Venetian patrician, the third Grand Chancellor of that family.[1] He attained this high rank through his merit and integrity and his house was a meeting place for all talented men.

He was honoured by the visits of prelates, cardinals, and princes who from time to time came to Venice, desirous of seeing their faces immortalized by his sublime brush. Besides the king of France and Poland, already mentioned, he portrayed many dukes and lords of Italy and other princes and barons from beyond the Alps, and also, as we have said, all the doges of Venice who lived in his time. Their portraits are also conserved in their families' houses. The portrait of Doge Pietro Loredan is kept by Signor Giovan Francesco Loredan, the revered writer whom we have discussed elsewhere.

For the King Arima Harunobu, the King of Bugno and Chikuzen (Otomo Sorin), and the Prince Vamusa (Omura Sumitada), he also painted the portrait of

1. Lost

Opposite: Portrait of Doge Pietro Loredan, 1567–68

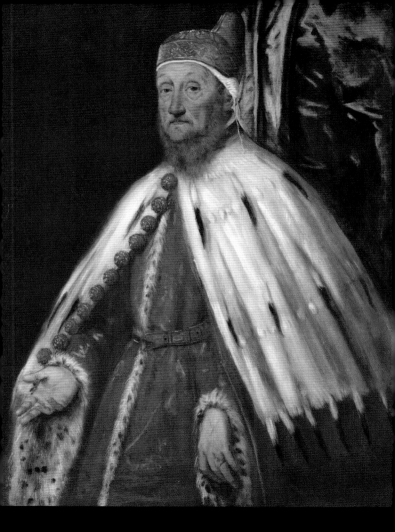

Lord Ito Sukemasu Mancio, the nephew of the King of Fiunga; Lord Miguel Chijiwa, the nephew of King Arima, also called Lord Protasius; Lord Julião Nakaura and Lord Martinho Hara, Japanese Barons of the Kingdom of Fighem, ambassadors to the Holy See who also visited Venice in 1585. On a commission from the government he also made another painting of them as a record of their visit. The portrait of Lord Mancio was seen in the painter's own home.[1] Likewise the royal and princely ambassadors who resided in Venice were ordinarily painted by him.

Above all things Tintoretto sought glory. All his many efforts were to this end. His only thought was to open the path to immortality, putting at naught all human happiness, valuing only the delight that one derives (as the wise man says) from doing that which is perfect. This alone is the goal of noble spirits, since Fortune's goods are often divided among many. But genius is a ray of grace that God is pleased to give only to a few, so that we may recognise the special gifts of His divine hand. Fortunate is the one who in this life wears the mantle of genius.

At times he lamented that he was unable to

1. Domenico Tintoretto, *Portrait of Ito Sukemasu Mancio*, 1585; Milan, Fondazione Trivulzio. The other paintings are lost

exercise all the facets of his talent, being impeded by excessive work and sometimes oppressed by family burdens. Without doubt if he had had the opportunity to paint as he wished (for his talent was equal to any task), even greater effects would have been seen from his fortunate brush. But the vagaries of fortune very often deflect the mind from its best work, and spirits battered by turbulence at times cannot function properly. Whence it was wisely said:

SWANS MUST HAVE PLEASANT NESTS, HIGH FEEDING, FAIR
WEATHER TO SING: AND WITH A LOAD OF CARE
MEN CANNOT CLIMB PARNASSUS CLIFF.

Nevertheless, from the many works that we see by his hand one may truthfully conclude that Tintoretto was endowed with those noble qualities that count most in placing a painter at the sublime level of an art so excellent and rare. Painting was likewise adorned by his hand with the most rare and exquisite forms and the most unusual aspects of beauty that were ever produced in art, for with ingenious theft he robbed all the rarest objects of their beauty in order to embellish his figures. Thus with the death of Tintoretto painting was left both in learning and in art only with hope. Among his numerous works we mention only the following: the two great paintings in the church

CARLO RIDOLFI

of the Madonna dell'Orto; the painting of the Mira-
cle of the Slave in the confraternity of San Marco;
the two of the Scuola della Trinità; the Crociferi Fa-
thers' altarpiece of the Assumption; the works in the
church of San Rocco; the Crucifixion of Christ and
the paintings in the Albergo of that confraternity; the
Recovery of Zara and, finally, the great canvas of the
Paradise in the Ducal Palace. Each of these paintings
by its excellence would suffice to render his name ever
bright and glorious.

These were the most noted and outstanding deeds
of our new Apelles. To speak of his work *in extenso*
would require a more ample discourse and a more
effective pen. Without doubt, many of them are scat-
tered about in various places, bringing their number
toward infinity, since Tintoretto spent his time and his
talent tirelessly and excellently. With his glorious ef-
forts he showed the world the splendours of a sublime
talent that in defiance of time and envy will always by
mortals be revered. The works of such a great artist
will serve in the future as testimonials of a supernatu-
ral genius produced by God for the marvel of the ages.

But as it is the law of Nature that everyone ren-
der unto death his mortal remains, when Tintoretto
reached his eighty-second year, weak and drained in
strength by his great age and past labours, he lapsed

into an illness of the stomach which for fifteen days kept him continuously awake. The doctors used all their art to make him sleep, thinking in that way to restore him. Nevertheless the malady advanced, since every remedy is vain when death is destined by Heaven. Then he thought of putting his affairs in order and rendering his soul into the hands of the Creator; with signs of Christian contrition he fortified himself with the Most Holy Sacraments. Later he called his sons Domenico and Marco to his side and with many tears he said goodbye, exhorting them at the same time to preserve the honour that he had won in the world at the cost of long labours and vigils. He asked them also to keep his body uninterred for three days, thinking that sometimes the sick, having fallen into some sort of faint, appear to be dead. Thus on the third day of Pentecost of the year 1594, with a brief sigh, his soul made the passage from earth to Heaven. The funeral procession leading to the church of the Madonna dell'Orto, where he was buried, was followed by a throng of painters who wept at the death of their master, by important personages, and by his loved ones whose hearts grieved at the loss of such a precious friend. He was buried in the vault of his father-in-law, Marco Episcopi, beneath the choir, to the accompaniment of honourable obsequies.

Thus by keeping to the laborious path of virtue through the long course of his life, Tintoretto reached glory, which was his goal. Through his efforts he gathered palm and laurel, ending his days with honour and acclaim. The memory of his famous name, like the turning of the planets and like time itself, will remain immortal.

Many fine minds have mourned his death and celebrated his valour with brilliant words. But it will suffice here to note the funeral elegy inscribed over his ashes by Signor Jacopo Pighetti, the most celebrated author of our age, and by some of the writings of the most melodious poets.

VISITOR, TRAVELLER, CITIZEN,

STAND AND READ THROUGH:

THE ASHES OF

JACOPO ROBUSTI

KNOWN AS

TINTORETTO

ARE BY THIS MARBLE HERE ENCLOSED.

THIS GREAT IMITATOR OF NATURE

BY HIS POWERFUL TALENT MADE SILENT POETRY

SPEAK

AND WITH DIVINE BRUSH

BROUGHT TO LIFE AND BREATH WITHIN HIS PAINTINGS

INHABITANTS OF SUNLIGHT AND OF HEAVEN

THESE WILL VORACIOUS TIME, ADMIRING, GUARD.

IN THE TEMPLE OF IMMORTALITY FAME WILL PLACE

FOR ALL ETERNITY

RECOGNITION OF HIS PAINTING AND HIS WORLD.

YOU WHO READ THIS PRAY

FOR THE WELL-BEING OF SO FINE A MAN

AND THEN REJOICING, GOD

This man painted all things in all modes
He himself became all sorts of painters,
he was one for all.
No other age will produce another like him
From this time forward he will be one for all.
Though Tintoretto did not bring
Active figures to life
Yet he was not less than Pygmalion
Who brought to life but one.
For from his soul to thousands he gave life unending.

By M. Antonii Romiti I. C.

The Mirror of Nature,

Artificer divine, magic painter,
With glorious care
To shadow you gave spirit and to colour, soul;
To the dim and motionless eye,
Sparkling light and loving movement.
Ivory he made come alive
And penetrating into hidden flames of love,
He painted moist lips
In which one senses loving murmurs.
He gave expression to playing and to singing,
Laughter he made joyous and lamentation wan.
To the dead he gave life
With the quickening of his lifegiving colour;
It is a boundless marvel
To make with art the mortal face immortal.
And when the eyes he painted
With images of sense he senses conquered.
Night he displayed, and all about
Amid the shadows and terrors wand'ring spectres
he made.
Light he gave to day,
Bright to the sky and tempests to the sea;
And to the eye disclosed
In visible form the Heavens, Angels, God.

Now bright and burning He follows longed-for loves,
With them at dawn
He blends his heavenly hues
Tints the first rays of dawn,
And in the sky a lovelier sky unfolds.

By Sig. Cavalier Guido Casoni

Weep Adria, not alone, but with Italy and the
whole world.
Extinct is Tintoretto in whom God
Joined Art together with Design and then
Adorned him both with grace and thoughts
profound.
He died, yes; but this fleeting form laid by,
With pious prayers he turned toward Heaven above
To contemplate that which his works contained
And what his learned fertile style revealed.
That which he did on earth, that which he knew,
Of Heaven's glory and the Beatified
And apprehended with his mind divine:
At last those mysteries, deep and most concealed,
With the light kindled by Eternal Love
In the Supreme Mover now he sees revealed.

By D. Filippo Ridolfi

A Portrait of Tintoretto

In Venice born, as a young boy I dared
To follow in the worthy Titian's path.
But in that school my talent served but to
 Inculcate envy and to kindle rage.
Nature I conquered, Death I overcame
With study, genius, and with daring too;
And with my brush I reached the highest plane
Of art both in the hues and the design.
 No work ere mine did truly represent
The violence and the fury raised by Mars,
The frightful slaughter and how Death itself,
Enraged and savage, reigns in every part,
Then into glorious tumult all is changed.
Assaults and combats with my art I show
And from defeated and from demolished ranks
Bring back as trophies flags and arms of war.
 When in a lovely countenance I joined
Colour and line, all were enthralled, and Love,
To take in conquest still more hearts and souls,
Made of my brush the torch and then the bow.
 To pullulate with putti and with Graces
And various delights that please the eye,
I made the ugly beautiful and made the feigned
Appear alive within my picture's frame.

Now Muses with their soft sweet songs do pass
The tranquil hours with me, and with them I
Draw the cartoons, and they meanwhile prepared
Panels and canvases to music's sounds;
The amorous goddess did her robe ungird,
Revealed her milkwhite flesh, her locks unfurled,
So that her beauty, filled with charm and joy
Formed an eternal model for the world.
I showed how in a body filled with life
The muscles tighten and emotions grip;
That which to earth gives nurture and abounds
In cavernous horrors of some far-off cove,
The tempests of the sea, and salty waves
That inundate and yet can still allure.
For in the end the subject of my brush
Was that which God and Nature did create.

By the Author.

Following pages: Angel and *Virgin*, fragments from
the *Annunciation to the Virgin, c. 1560*

List of illustrations

All oil on canvas unless otherwise noted

p. 52: Contest of Apollo and Marsyas, 1544-45, 139 x 240 cm,
Wadsworth Atheneum Museum of Art, Hartford

pp. 56-57: Miracle of the Slave, 1548, 415 x 541 cm,
Gallerie dell'Accademia, Venice

p. 60: Gentleman with a Gold Chain, c. 1555, 103 x 76 cm, Prado, Madrid

p. 66: Possibly Domenico Tintoretto after Jacopo Tintoretto, Portrait of a Lady
(Veronica Franco?), c. 1580, 61 x 47 cm, Worcester Art Museum, Worcester, MA

p. 69: Danaë (with workshop assistance), c. 1580, 142 x 182 cm,
Musée des Beaux-Arts, Lyon

p. 72: Assumption of the Virgin, c. 1560-65, 437 x 265 cm,
Obere Pfarrkirke, Bamberg

p. 77: Studies of a Statuette of Atlas and a Figure Praying, 1549, 25 x 39 cm,
black chalk heightened with white chalk, J. Paul Getty Museum, Los Angeles

pp. 86-87: Christ Washing the Feet of the Disciples, 1548-49,
210 x 533 cm, Prado, Madrid

pp. 90-91: Creation of the Animals, 1550-53, 151 x 258 cm,
Gallerie dell'Accademia, Venice

pp. 97-98: Details of The Last Judgment, c. 1559-60,
whole painting 1450 x 590 cm, Church of Madonna dell'Orto, Venice

p. 103: Detail of Miracle of the Slave, 1548, whole painting 415 x 541 cm,
Gallerie dell'Accademia, Venice

p. 104: Finding of the Body of St Mark, c. 1564, 396 x 400 cm,
Pinacoteca di Brera, Milan

p. 107: Theft of the Body of St Mark, c. 1564, 398 x 315 cm,
Gallerie dell'Accademia, Venice

p. 108: St Mark Rescues a Saracen, c. 1564, 398 x 337 cm,
Gallerie dell'Accademia, Venice

pp. 114-15: St Roch in Prison Comforted by an Angel, 1567, 300 x 670 cm,
Church of San Rocco, Venice

pp. 122-24 and detail p. 125: The Crucifixion, 1565,
Scuola Grande di San Rocco, Venice

p. 128: The Brazen Serpent, 1575-76, 840 x 520 cm,
Scuola Grande di San Rocco, Venice

pp. 132-33: The Miracle of the Loaves and Fishes, with workshop assistance,
c. 1545-50, 154 x 407 cm, Metropolitan Museum of Art, New York

p.147: The Evangelists Mark, John, Luke and Matthew, 1557, on two organ shutters, each 257 x 150 cm, Church of Santa Maria Zobenigo, Venice

pp.150-51: Presentation of Christ in the Temple, c.1554-56, 239 x 198 cm, Gallerie dell'Accademia, Venice

p.157: St Martial with the Apostles Peter and Paul, 1549, 376 x 181 cm, Church of San Marziale, Venice

p.163: Bacchus, Ariadne, and Venus, 1578, 146 x 167 cm, Doge's Palace, Venice

pp.168-69: Doge Alvise Mocenigo Presented to the Redeemer, 1571-74, 97 x 198 cm, Metropolitan Museum of Art, New York

p.170: Portrait of the Procurator Alessandro Gritti, with Domenico Tintoretto, c.1580, 99 x 75 cm, Museu Nacional d'Art de Catalunya, Barcelona

p.173: Battle at Riva del Garda, c.1579,424 x 568 cm, Doge's Palace, Venice

p.178-79: Recovery of Zara, c.1582-87, with workshop assistance, 640 x 1060 cm, Doge's Palace, Venice

p.184: Origin of the Milky Way, 1577-79, 149 x 168 cm, National Gallery, London

p.187: Portrait of a White-Bearded Man, c.1555, 92 x 60 cm, Kunsthistorisches Museum, Vienna

p.188: Deucalion and Pyrrha in Prayer, from the Fables of Ovid, 1541-42, oil on panel, 127 x 124 cm, Galleria Estense, Modena

pp.190-91: The Abduction of Helen, c.1578, 186 x 307 cm, Prado Museum, Madrid

pp.194-95: The Conversion of St Paul, c.1544, 152 x 236 cm, National Gallery of Art, Washington, DC

pp.198-99: Doge Alvise Mocenigo and Family before the Madonna and Child, c.1578, 216 x 416 cm, National Gallery of Art, Washington, DC

p.201: St George and the Dragon, 1553-55, 158 x 100 cm, National Gallery, London

pp.204-5: Summer, 1546-48, 105 x 193 cm, National Gallery of Art, Washington, DC

pp.210-11: Susannah and the Elders, c.1555, 146 x 193 cm, Kunsthistorisches Museum, Vienna

p.213: A Procurator of Saint Mark's, c.1575-85, 138 x 101 cm, National Gallery of Art, Washington, DC

Photography on pp. 1, 262, and 263 courtesy Rijksmuseum; on pp. 2, 26, 36-37, 46, 49, 114-15, 122-24, 125, and 128 courtesy Scuola Grande di San Rocco; on p. 4 courtesy Art Institute of Chicago; on pp. 6, 14, 23, 25, 30, 38, 52, 60, 69, 72, 86-87, 90-91, 97, 98, 104, 147, 157, 163, 170, 173, 184, 187, 188, 190-91, 201, 210-11, 216, 227, 229, 242-43, 246-47, and 251 courtesy Wikimedia Commons; on p. 9 courtesy Philadelphia Museum of Art; on p. 19 courtesy Art Gallery of South Australia; on p. 20 courtesy Morgan Library and Museum; on pp. 42-43, 56-57, 66, 103, 107, 108, 150-51, 178-79, 215, and 224-26 © Bridgeman Art Library; on p. 60 courtesy Detroit Institute of Art; on p. 77 courtesy J. Paul Getty Museum; on pp. 132-33, 168-69, and 236-37 courtesy Metropolitan Museum of Art; on pp. 194-95, 198-99, 204-5, and 213 courtesy National Gallery of Art, Washington, DC

267

© 2019 Pallas Athene

Published in the United States of America by the J. Paul Getty Museum, Los Angeles
Getty Publications
1200 Getty Center Drive, Suite 500
Los Angeles, California 90049-1682
www.getty.edu/publications

Distributed in the United States and Canada by the University of Chicago Press

Printed in China

ISBN 978-1-60606-600-3

Library of Congress Control Number: 2018953954

Published in the United Kingdom by Pallas Athene
Studio 11A, Archway Studios
25–27 Bickerton Road, London N19 5JT

Alexander Fyjis-Walker, *Series Editor*
Anaïs Métais, *Editorial Assistant*

Front cover: Tintoretto (Jacopo di Giovanni Battista Robusti), *Self-Portrait*, ca. 1546–48.
Oil on canvas, 45.1 x 38.1 cm (17¾ x 15 in.). Philadelphia Museum of Art, Gift of Marion R. Ascoli
and the Marion R. and Max Ascoli Fund in honor of Lessing Rosenwald, 1983, 1983-190-1

Note on texts:
Carlo Corsato translated the notes by El Greco and Annibale Carracci, as well as the letter by
Veronica Franco, with Frank Dabell; and the letter by Calmo with Lorenzo Buonanno.
Previously published translations of Giorgio Vasari's *Life* by Gaston de Vere, of Aretino's letters
by Judith Landry, and of Carlo Ridolfi's *Life* by Robert and Catherine Enggass, were edited,
corrected and revised by Carlo Corsato with the assistance of Frank Dabell.